BEHIND THE
SHUTTER

THE DIGITAL WEDDING
PHOTOGRAPHER'S GUIDE
TO FINANCIAL SUCCESS

Salvatore Cincotta

AMHERST MEDIA, INC. ■ BUFFALO, NY

DEDICATION

This book is dedicated to my amazing wife, whose unending love and support have made this possible.

Published by:
Amherst Media, Inc.
P.O. Box 586
Buffalo, N.Y. 14226
Fax: 716-874-4508
www.AmherstMedia.com

Publisher: Craig Alesse
Senior Editor/Production Manager: Michelle Perkins
Assistant Editor: Barbara A. Lynch-Johnt
Editorial Assistance from: Carey A. Miller, Sally Jarzab, John S. Loder
Business Manager: Adam Richards
Marketing, Sales, and Promotion Manager: Kate Neaverth
Warehouse and Fulfillment Manager: Roger Singo

ISBN-13: 978-1-60895-264-9
Library of Congress Control Number: 2011924266
Printed in The United States of America.
10 9 8 7 6 5 4 3 2 1

Check out Amherst Media's blogs at: http://portrait-photographer.blogspot.com/
http://weddingphotographer-amherstmedia.blogspot.com/

TABLE OF CONTENTS

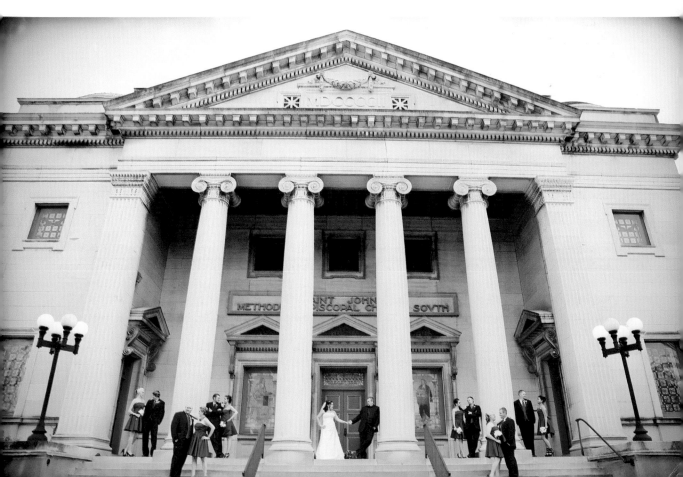

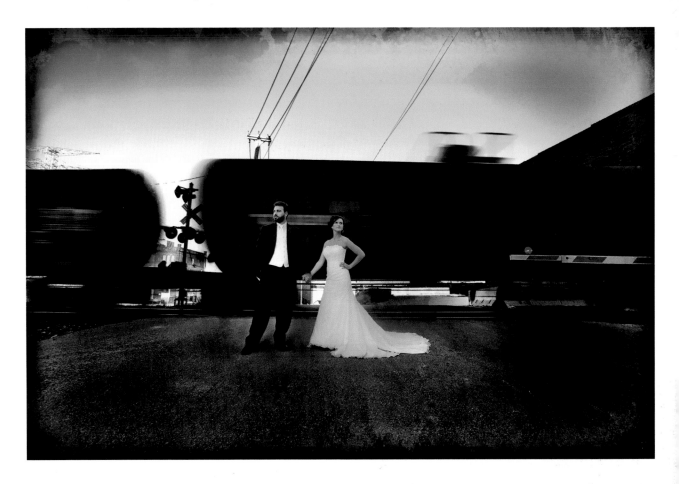

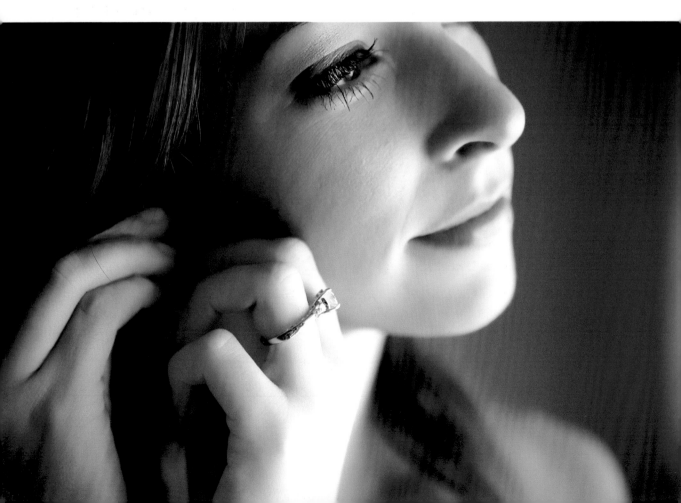

ABOUT THE AUTHOR

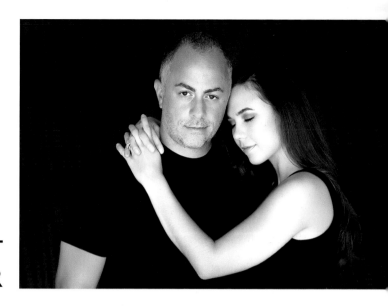

Sal Cincotta is the owner and principal photographer of Salvatore Cincotta Photography and Studio C, based in O'Fallon, IL. Sal was initially exposed to photography at a very early age, playing around in his aunt's darkroom. Assisting and second shooting at weddings as a teenager, his love for photography was born. Because he saw photography as more of a hobby than a career, however, he opted to attend business school. After receiving his business degree from Binghamton University in New York, Sal left college for the corporate ranks in 1997. There he worked for Fortune Top 50 companies like Microsoft and Procter & Gamble, honing his skills with some of the most brilliant business and technical minds in the world.

In early 2006, the corporate grind had taken its toll and Salvatore Cincotta Photography was born. Sal knew great pictures alone wouldn't guarantee success, so he established his studio around a solid business and marketing plan to ensure he could actually make a living pursuing his passion. Since turning pro in 2007, Sal and his wife Taylor have quickly established themselves as a major studio, covering events in New York, Chicago, Saint Louis, and abroad.

Today, Salvatore Cincotta Photography photographs over fifty weddings, 120 seniors, and a multitude of families every year. A second venture, Studio C, photographs over two-hundred seniors each year in addition to servicing families and children/babies. The business has also expanded into the world of cinematography, with a new company, aptly named Salvatore Cincotta Films, dedicated to producing short films for wedding clients.

Sal also writes for *Rangefinder* magazine and has created BehindTheShutter.com as a training resource for professional photographers.

FOREWORD

Why write this book? That is the first question I get asked. It's quickly followed by this one: Aren't you worried that everyone will know your secrets? The short answer is no, I'm not afraid—not at all. A project like this is about raising the bar for our industry and giving back to a community of people who are hungry and curious to learn.

I am writing this book because I felt it needed to be written. It is my way of giving back. Our industry is littered with subpar studios/photographers who give all of us a bad name. Now, before you get all huffy, hear me out. This is not a slam on our industry. I am, after all, a professional photographer. I love my job! I take tremendous pride in our craft and the responsibilities given to us by our clients. However, with the advent of digital, it has become easier and easier for the weekend warriors to make their mark—and sometimes that mark is more of a burn.

When I was starting out, there were plenty of books out there on lighting and posing, but there seemed to be very few books about the business of photography. And the books that were out there seemed, well, very dated. Again, this is not a slam, more of a reality check. After reading those books, I was left with so many questions and nowhere to go for answers. They seemed to present an old-school way of doing business—and our studio's brand is anything but old-school.

I am writing this book because I felt it needed to be written.

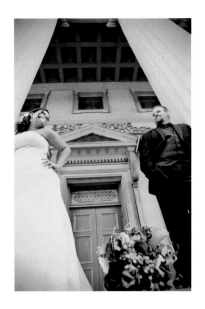

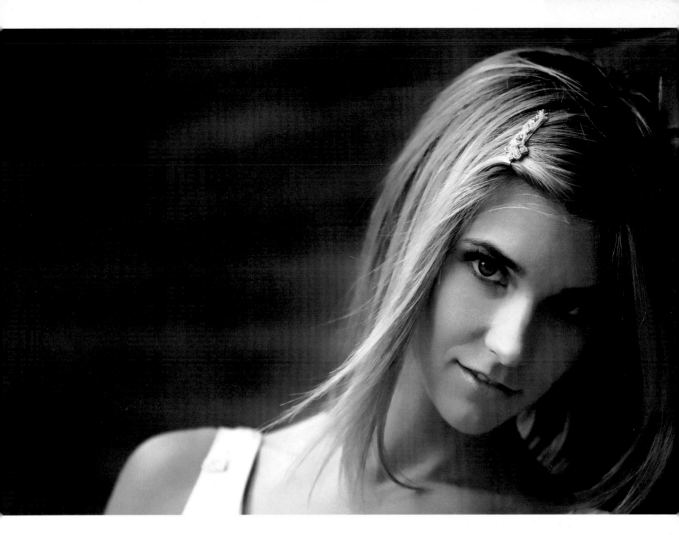

The industry has changed so much in the short time we have been part of it and it shows no signs of slowing down. One thing I learned in my years at Microsoft is that the only constant is change. Studios are faced with challenges galore, but none are more significant than the force of change. In today's marketplace, it is almost impossible to set up shop and implement a single strategy for five, ten, or fifteen years. Fortunately, as photographers we are visionaries by nature; we must use this vision to see the future and predict how it will impact our business, then adjust our road map accordingly.

Part of the reason so many studios are struggling is because they are having trouble navigating in these new and ever-changing waters. We have grown over 30 percent each and every year we have been in business, and the coming year shows no signs of slowing down for us. We are a studio based in a blue-collar Midwestern city— so if we can do it here, you can implement our strategy anywhere in the world and find success.

So, how do we do it? Trust me, it's a lot of hard work, a lot of eighteen-hour (or more) days, and a lot of coffee. In the end, you must implement solid, foundational business practic-

es. As artists, this is not something that comes easily to most of us. That's where this book comes in. Use it as your planning tool and an educational resource. Don't read it once and put it down; use it and refer to it often.

Am I worried about everyone knowing our secrets? The reality is, this book is a blueprint. How you implement this blueprint into your own business practices will differ from how I implement it in mine—and how anyone else

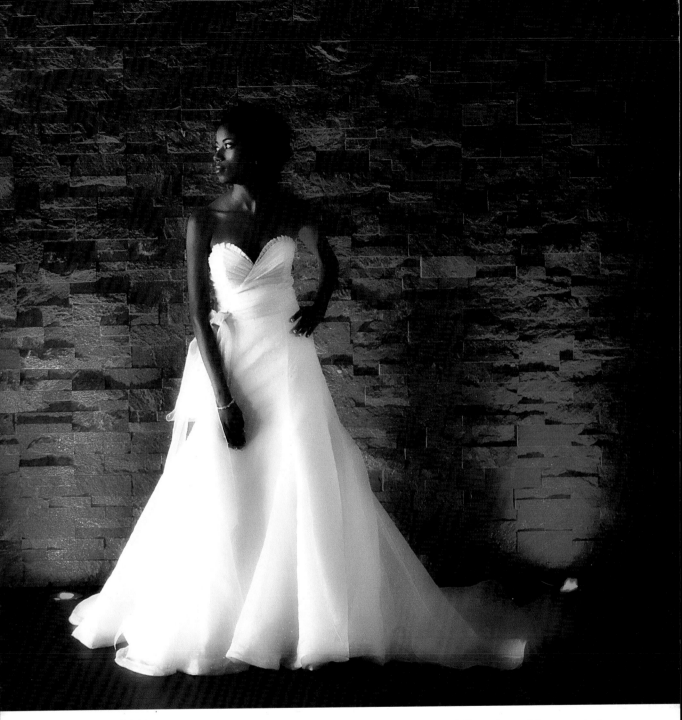

might put it to use in their studio. There is nothing magical to what we do. It's our XFactor that allows us to take something that everyone can do and turn it into a thriving and profitable business. (We will talk about *your* XFactor and how to harness it later in the book.)

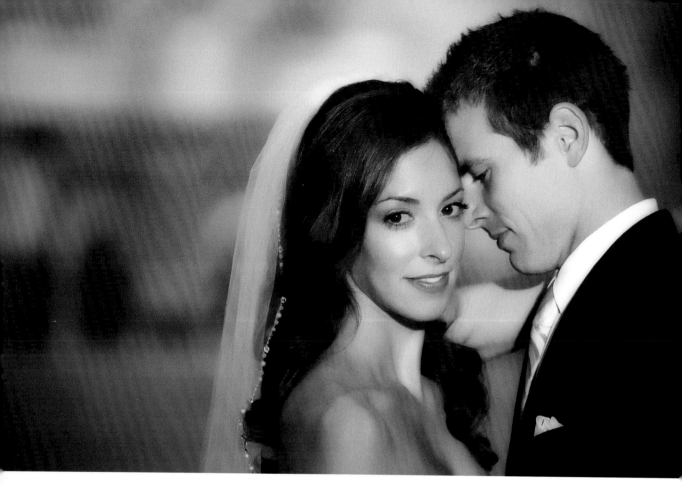

Just know that knowledge truly is power. Take the knowledge you gain in this book and do something with it. The worst thing you can do is put all this information on the back burner. You should be taking notes throughout the entire book, and you should start implementing changes in your business immediately. Nothing would make me happier than seeing more photography businesses thriving—I *want* success for all my peers and for our industry as a whole. Every Saturday, when I go out to shoot a wedding, I know that I am an ambassador for our industry and I try to be the best ambassador I can be.

Keep shooting, and remember this: we are not just photographers. We are visionaries, directors, historians, storytellers, and entertainers—but most importantly, we are artists. Our job is one of the most important in history. Don't ever forget that—and don't ever feel apologetic for being successful.

We are visionaries, directors, historians, storytellers, and entertainers—but most importantly, we are artists.

1. WEDDING BUSINESS BASICS

It takes more than shooting a few friends' weddings to call yourself a professional.

So you want to be a wedding photographer. You picked up your nifty new kit camera at the local box store and you are ready to take on the world! Well, what happens when the world comes a'knockin'? If you are like the majority of newbies in the industry, you have no idea where to start from a business perspective. Sure, you have an eye. However, it's going to take more than an eye and a few family friends letting you shoot their weddings to call yourself a professional photographer.

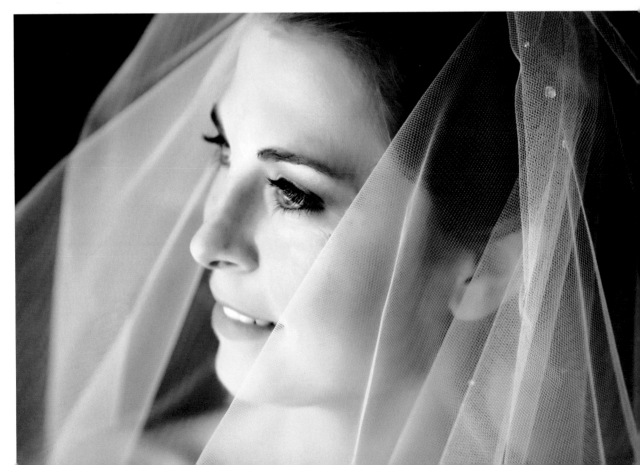

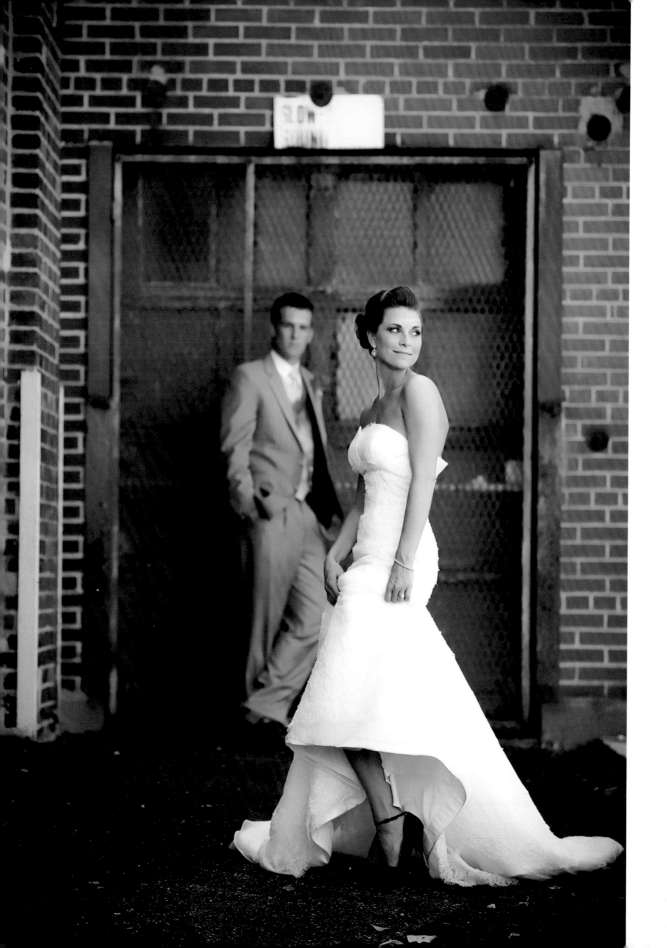

Whether you are new to the industry or a seasoned pro, this is a great starting point for your business.

You will be doing yourself, the industry, and your clients a huge disservice if you present yourself as a professional before making the necessary investments to ensure you are holding yourself to the highest possible standards. While there are organizations that offer professional certifications, they are geared more toward the technical aspects of creating an image. And as you will soon see, the release of the shutter is just the beginning of your journey.

Starting in this chapter, we are going to take a look at some business basics to ensure you are heading down the right path. Whether you are new to the industry or a seasoned pro, this is a great starting point for your business. And, sure, I know what you're thinking. "I'm just doing it on the weekend, for friends, etc. Do I really need to know about business? Can't I just shoot and hand them the CD?" No, you can't. Before you know it, jobs will be coming in and you will soon realize that "shooting and burning," as it is referred to in the industry, is not a business model. In the end, it will actually impede your ability to make a decent living and leave your clients wanting so much more.

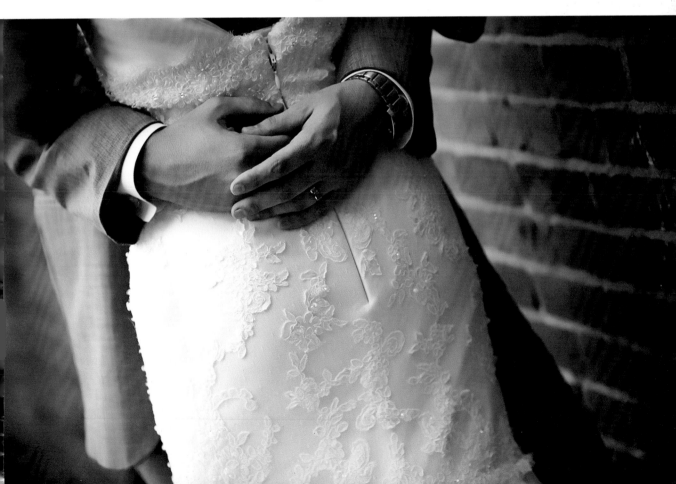

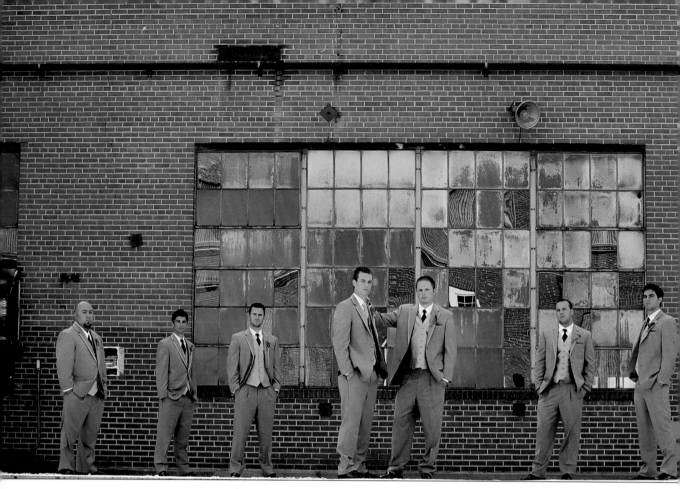

According to Salary.com, the average professional photographer makes less than $50,000 per year. I don't know about you, but I like the finer things in life—and I am a big believer in the entrepreneurial spirit. There is no reason you can't follow your passion and still make a decent living. We should not have to apologize for that. So, that being said, let's begin our journey.

PLOTTING A COURSE

Imagine, if you will, that we are on a road trip. Pick a place you have been dying to go, somewhere you'd like to take pictures, drink some coffee at an outdoor cafe, and maybe even do some sightseeing. Do you have something in mind? Okay. Now, tell me how we get there. Are we driving? Do we need to turn down certain streets? How long will the trip be? Do I have time for a nap? What should I bring on this trip? You would never go on

> There is no reason you can't follow your passion and still make a decent living.

a road trip without a map of some sort, some plan to guide you down the path to success—the path that ultimately leads to your destination. Are you getting the picture yet?

Well, the same holds true in business, except this trip will be navigated with your business plan. Yes, a business plan. One of the first things I want to see and discuss every time I consult with a professional photographer is their business plan. And more often than not, they don't have one. Having a business plan is one of the most basic things you can do to ensure success. It's the only way to ensure that you and your staff are all marching to the beat of the same drummer and heading toward your intended final destination.

Trust me—I understand your misgivings and apprehension. You want to be a photographer, not a business school graduate. So, let's embark on Sal's Business School Crash Course and begin to develop an understanding of some key terms and how they apply to your business and our industry. I will keep the definitions as simple as possible to ensure you get the point. I promise not to let you get bogged down in terminology.

THE BUSINESS PLAN

A business plan is a formal statement of your business goals and your strategy for reaching those goals. Think of it as the who, what, when, where, and why of your business. Regardless of your experience level, your plan should cover where you want to be (and how you plan to get there) in twelve months, three years, and five years. For us, we have a solid idea of where we want to go over the next three to five years. And, clearly, in order to get

Formulating a comprehensive business plan will help you reach all your goals.

there, certain things need to happen in the next twelve months.

This plan can be as formal or informal as you like. Obviously, if you are looking for some investment funding to get things started, you will need to be very formal in your plan. If you are like most small startups, writing out a business plan will be more of an exercise to document your direction and create your map. I like to keep it as simple as possible and maintain a notebook with all sorts of ideas, goals, and metrics (objective values that help you calculate your success).

What Should Be in Your Initial Plan? At a minimum, you should identify your niche. Since you are reading this book, you obviously want

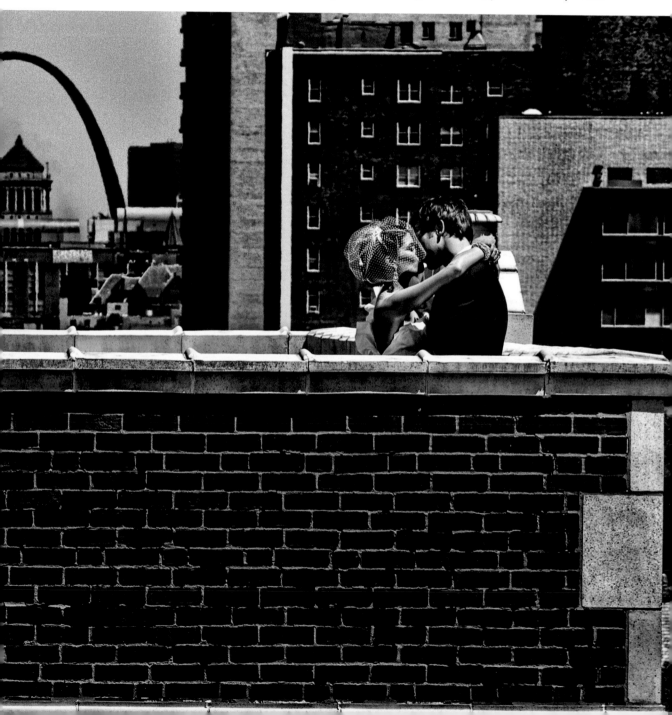

to go after weddings. But how about seniors, babies, families, etc.? Will those niches also be a component of your business?

How many weddings would you like to shoot? The answer cannot be, "I want to shoot as many as I can book!" That would be disastrous, because along with all these bookings comes the responsibility of delivering on them.

How much are you planning on charging? Sure, this is a loaded question. Each market is different, so you have to look at your competitors, what they are offering, how much they charge, etc. I am not in any way, shape, or form, suggesting that you copy your competitors' packages (that would be ridiculous), but you do need to evaluate the competition as a gauge for your local market. You also want to compare your style of photography, product offerings, time, etc. You want to be competitive. Later on, I will talk more about putting packages together.

What will you offer? Will you be a low-cost photographer looking to hand over a CD of images? Or will you be more of an

You need to evaluate the competition as a gauge for your local market.

How does the style of photography you offer compare with that of other businesses in your market?

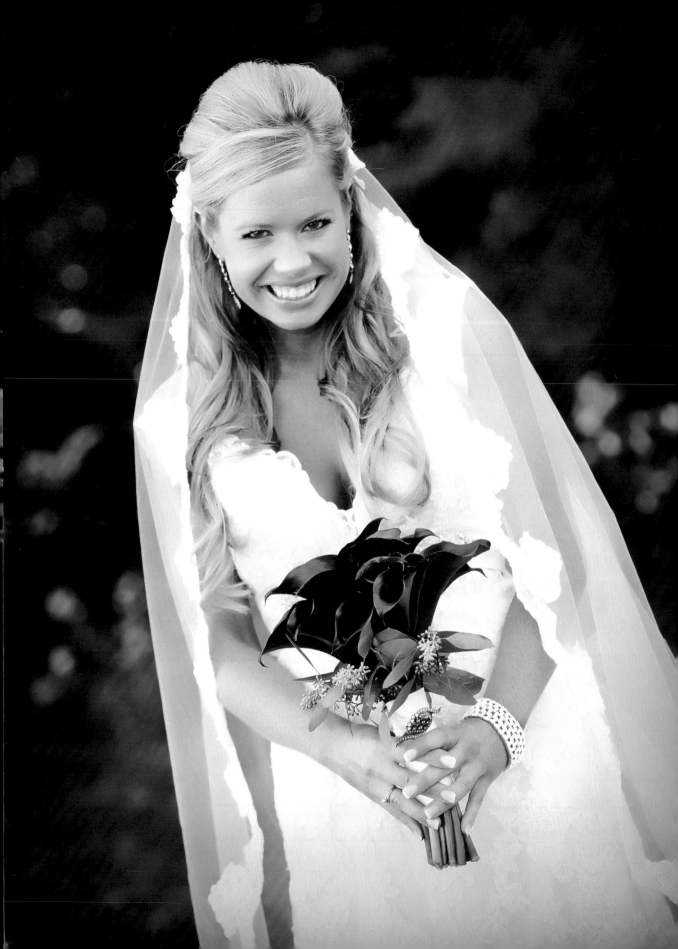

artist, a craftsman of sorts, creating unique images and delivering them as high-quality products for your clients to enjoy?

How will you differentiate yourself in the market? What will you do to stand out from the crowd? What is your XFactor? Today, everyone is a photographer, which is fine—but you have to stand out from the crowd in order to survive.

These are just some simple and painless ways to start your business or even re-evaluate it to ensure you have a clear path mapped out that everyone involved in the business can follow.

Our Goals. When we first started out, our goals were very simple. In 2007, we wanted to shoot fifteen to twenty weddings at $3,000 each and twenty-five high school seniors at an $800 average. Today, our numbers have changed dramatically and our plan has become much more detailed. By 2011, we were look-

> How will you differentiate
>
> yourself in the market?
>
> What will you do to stand
>
> out from the crowd?

We are in blue-collar country with a seven-month shooting season. If we can do it here, you can make our system work anywhere.

So, hopefully you get the point here: you *must* put a business plan together. However, you should not confuse your business plan with your marketing plan.

THE MARKETING PLAN

If your business plan is *what* you plan on doing, your marketing plan is *how* you plan on doing it. It's not enough to say that you want to shoot thirty or forty weddings. Setting that goal is great . . . but how are you going to accomplish it? That's the big question and the more difficult challenge.

There are several approaches to consider. Will you go after vendors and planners, bridal shows, magazine ads, television, direct mail, Google, or the slew of social media sites? All are viable options, but finding the formula that works best for you will take some work and experimentation. Ultimately, though, there is no magic bullet and I would recommend not investing too heavily in any single medium.

I won't delve too deeply into bridal shows at this point (I have a whole chapter dedicated to the topic coming up), but let's take a look at some other options.

Referrals. The wedding industry is an industry based on relationships—in the end, it's all about generating good referrals. So, how do you get these relationships? You develop them over time.

ing for fifty weddings at an average of $9,000 and over 120 senior sessions at an average well above our 2007 numbers.

How did we do it? We had a plan! We stuck to the plan, tweaked the plan as necessary, and continued to strive for excellence. And, again, keep in mind that we are in the Midwest—not in sunny southern California with the ocean, mountains, and year-round shooting weather.

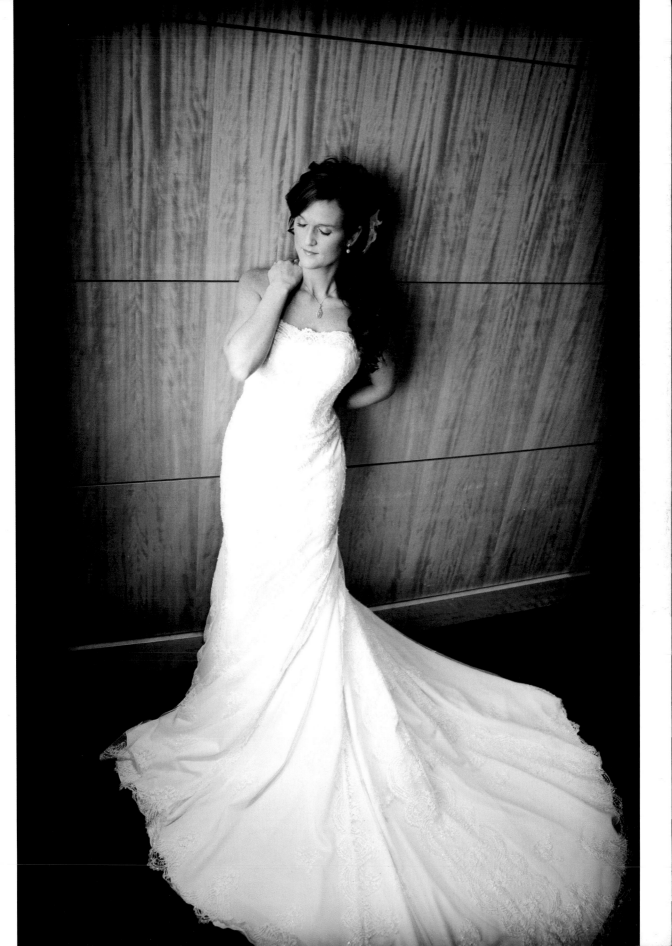

If you are just starting out, this could be about as much fun as rubbing your face against a stone wall. When we first started out, we went around to all the top venues in our area, introducing ourselves, showing our work, and asking what it would take to be on their preferred vendor list. They were all very nice about it, but in the end there was only one venue that believed in us and gave us a chance. Our very first year with them, we booked 75 percent of our weddings through that contact. To this day, I have never forgotten their support and we still do some free work for them when they need new pictures for their salesroom. We have even shot weddings for two of their employees and a multitude of associated family and baby shoots, so the investment we have made there over the years has more than paid its dividends. Today, we are on the preferred vendor list of all the venues we want to work with.

The take-away here should be that relationships take time to develop. Most vendors are bombarded by new photographers who want to get on their preferred list. So, don't give up and

Today, we are on the preferred vendor list of all the venues we want to work with.

don't get discouraged. Give it time, keep doing a great job, and eventually you will get to know these people on a personal level. That's when the real fun begins.

Radio and Television. What about television or radio? I have to admit, I have never tried radio—and I am in no hurry to do so. At the end of the day, we sell imagery. Given that radio is an audio-only medium, I'm not sure I would really be hitting my target.

Television is powerful, but it's a tough nut to crack. If it's done right, it can really set you apart; if it's not, it can be a costly mistake. When we first started out on television, we ran a $4,000 commercial with no return at all. But we didn't give up. In our market, we have several local stations that offer up their version of a morning show. We have become the resident photographers on one of those shows, and the exposure we have gotten from this

Give it time, keep doing a great job, and eventually you will get to know the key people on a personal level.

has been tremendous. Had we entirely abandoned television as a viable medium after that first disaster, we would not enjoy the success we do today with the local morning show. So, again, don't give up. Keep trying to find a way to make something work—and be sure you are measuring the results.

Magazines. Magazine advertising has been hit and miss for us. As brides become more and more Internet savvy, I wonder if this will go away completely someday. Here are my thoughts on magazine ads: it's all about exposure. To be effective, an ad has to get your name out there. People have to see your work and name over and over again. You don't want to be an unknown entity in your market. I am lucky enough to have a unique name and that definitely helps when you are branding your business.

Internet and Social Media. Finally, how about the Internet and social media (MySpace, Facebook, Twitter, etc.)? This is a topic I could write an entire book on. How important is it? It plays a monumental role in the success of your business. If you are new to the industry, get it together and make sure you have an Internet identity that matches your brand and showcases great picture. And if you are an old-schooler, get it together!

We have been in a transitional phase for a few years now. More and more, people want to sit in their home and look for photographers online. They find them in a variety of ways. I don't want to explore every single one of them, but they range from search engines and online magazines

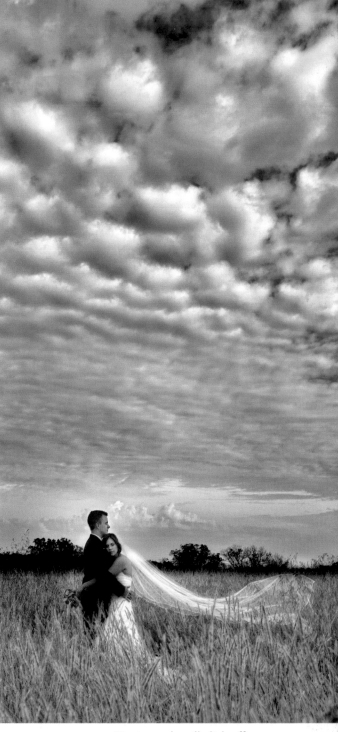

ABOVE AND FACING PAGE—Most people will click off your site in less than twenty seconds if you don't show them something that catches their eye.

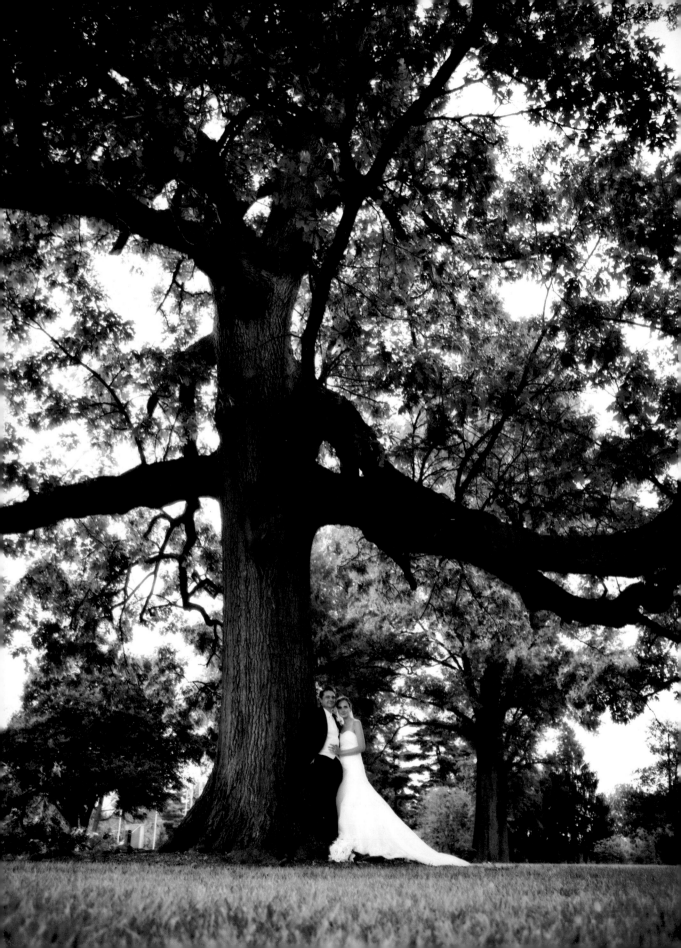

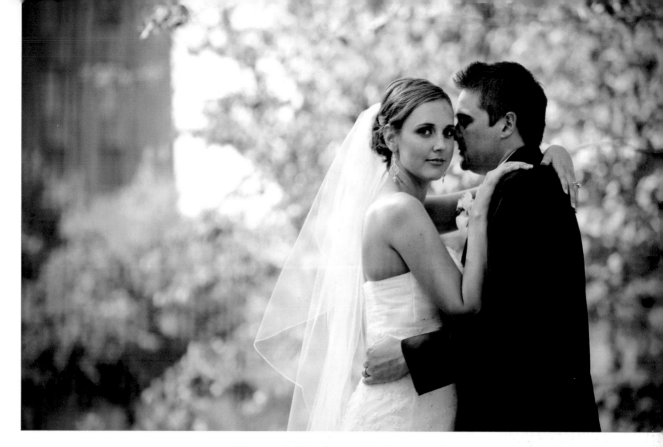

to blogs and friends' Facebook pages. The point is this: you have to have your online presence together. Most people will click off your site in less than twenty seconds if you don't show them something that catches their eye. Just as you have a business and marketing plan, your online presence needs a comprehensive strategy in order to get you where you want to go.

If you can create excitement before you ever meet with the client, you will find a lot of success.

Every day I learn something new about my brides and how they find us, and we're discovering that almost all of them are well versed in our blog and Facebook site (see chapter 3 for more on this). They look at the pictures, the slide shows, and the video, and they fall in love with us well before they ever meet us face-to-face. How's that for a marketing plan? As photographers, we're in the emotion business—so if you can create excitement before you ever meet with the client, you will find a lot of success.

Accordingly, we invest heavily in our blog and Facebook site. We know the power of this medium and post as many events up there as possible. It's easy to get caught up in your busy schedule

and not update your site—but, trust me, people are watching. Best of all, you get all this exposure for free!

Your marketing recipe will be different than mine, and that's okay. For all of us, what works best will continue to evolve and develop over time. Just be sure to keep tweaking your plan as market conditions and bookings dictate.

METRICS

So far, we have covered two major topics and their importance to your overall success. Now, I want to dig deeper into some metrics we use to run our business. While you may not need to re-view them every day, you do need to understand what they are and how they affect your bottom line. This is not an exhaustive list, just some of the key values we use in running our business.

Cost of Goods (COG). The number-one question I get asked by aspiring photographers is, "How should I price my work?" Without truly understanding COG, answering that question will prove impossible. Sure, COG sounds like something you might catch on a long weekend in Vegas, but this guy is your best friend when you are putting together pricing.

Often misunderstood or ignored altogether, your COG is the amount you pay to create the

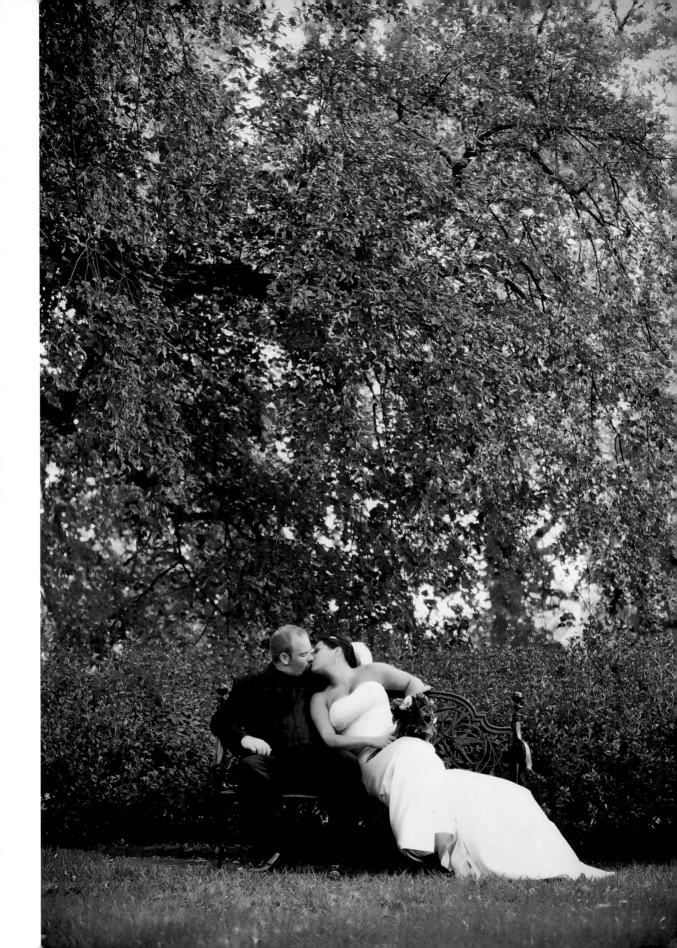

products you are selling to clients. This value includes the materials, labor, and overhead you invest to produce your final products. Understanding these costs is a very important part of being a business owner. It lets you know where you really have wiggle room and where you need to keep costs under control. Certain products or services will have more profit margin than others.

While it's easy to determine what you pay your lab to print an 8x10, things get considerably more tricky when it comes to putting a dollar value on time—especially when it's *your* time (as opposed to that of an employee who is paid an hourly rate). As the owner, I am typically wearing several hats. That makes it tough to figure out how much my time is worth on any given task. I have modified the COG formula for us and like to look at this number without *my* labor included. I know that this is not 100 percent true to the definition, but it works for me as a gauge. When we

Understanding product costs lets you know where you have wiggle room and where you need to keep costs under control.

ABOVE AND FACING PAGE—The cost of acquiring each new client must be balanced against the income derived from the sale to them.

Cost of Acquisition (COA). The COA is the price you paid to get a client. This is a very important number to keep an eye on—even though you won't see this metric mentioned many places and I'd bet that even a lot of seasoned pros don't keep an eye on it.

No matter how you acquire new bookings, there is typically a cost associated with the process (unless, of course, you have that referral engine really well-tuned). We do a lot of bridal shows. Some cost as little as $500 to attend, while others cost well over $6,000 to be part of. Needless to say, if we attend a show that we paid $6,000 to be part of and only book one wedding from it, we spent $6,000 to acquire that bride. That's not a very good number at all.

There are two ways to use the COA value. First, you can calculate it on an event-by-event basis. For example, if we paid $500 for bridal show X and booked four brides, the COA is $125 ($500 ÷ 4 = $125). Alternately, you can calculate your COA for the year as a whole. For example, we booked forty brides and participated in eight shows totaling $8,000, so our COA is $200 per bride ($8,000 ÷ 40 = $200).

Why do I look at these numbers two different ways? Because the elite bridal shows are going to have a higher COA than the average bridal show. That's okay. However, if your COA gets out of control, you are going to be working for free. I like to keep my COA at less than 10 percent of my overall sale.

Contract Average. Each client will contract with you for a certain dollar amount depending

have employees or other vendors involved, the number is much easier to calculate.

When we are putting packages together, I like to keep my product costs under 15 percent. This gives us the margins we need to include labor, outsourcing, packaging, etc.

on how you have your packages structured. The average dollar value of these sales is your contract average. For example, let's say you book three weddings at $3,000, $4,000, and $5,000 respectively. Your contract average for these events would be $4,000 ([$3,000 + $4,000 + $5,000] ÷ 3 = $4,000).

Why is this number important? Because it allows you to do some forecasting and have an understanding of where your business is heading—whether you are trending upward or downward over time. It's a mistake to gauge your progress based on either the lowest wedding you booked or the biggest event you had this year. You need to know your average. From there, you will be able to adjust your pricing over time and ensure people are contracting at the price point you are looking for.

Total Spend. The contract average is just one piece of the puzzle. The "total spend" reflects how much the client has spent with you after the contract—including, for example, engagement pictures and post-wedding sales. We have had clients contract with us for $3,000 and spend another $4,000 on engagement and post-wedding prints for a total spend of $7,000. You can then take that a step further and determine the average total

The "total spend" reflects how much the client has spent with you after the contract . . .

spend. This is calculated by taking the total amount spent across all weddings and dividing it by the total number of weddings.

Again, this information is great for forecasting and figuring out your sales averages. You should not be running your business based on guesswork. When you're working as a photographer, there are no guarantees—but it sure is nice to be able to predict with 90 percent accuracy what your sales will look like for the year ahead based on the established averages. You can then use that information in your planning for next year's growth.

This information is great for forecasting and figuring out your sales averages.

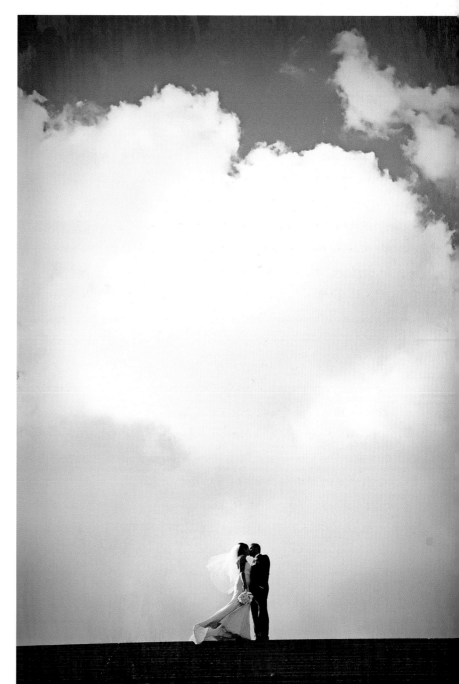

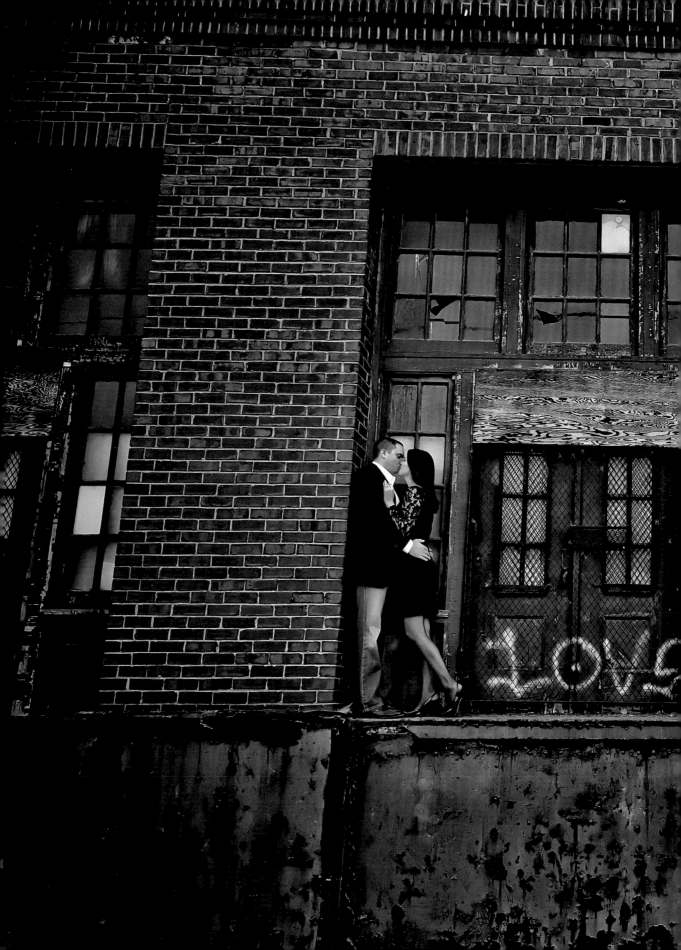

A PRICING EXERCISE

Here is an exercise you need to go through in order to understand the importance of pricing. Let's start with an engagement session. We shoot our engagement sessions on location and usually spend about an hour and a half with the client. We then edit the images—let's say that takes us an hour. Then, after about two weeks, the client comes in to see their pictures and we spend an additional two hours reviewing and picking their images. At this point, we have 4.5 hours invested in the shoot.

Now, let's consider selling a 4x6-inch print. I start with this size because it's where I see a lot of mistakes in pricing, but the concepts are the same for any print size or product you want to offer. In fact, we refer to 4x6s, 5x7s, and 8x10s as "gift" sizes and price them all the same. Why? Because, in all reality, it costs me the same to produce all three of them.

When calculating the cost of that 4x6-inch print, you have to keep in mind that you have about 4.5 hours invested in it. Nonetheless, I see a lot of new photographers asking $15 or less for these prints. If you are in this range, you are without a doubt losing money! When your client comes in and says, "Well, we just

Here is an exercise you need to go through in order to understand the importance of pricing . . .

Here is an exercise you need to go through in order to understand the importance of pricing . . .

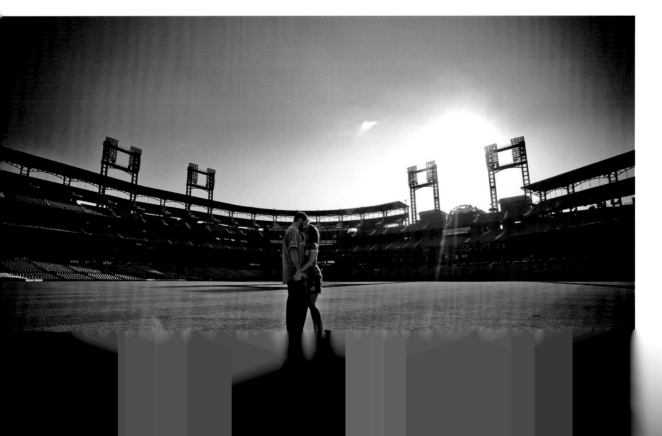

BELOW AND FACING PAGE—We shoot our engagement sessions on location and spend about an hour and a half with the client.

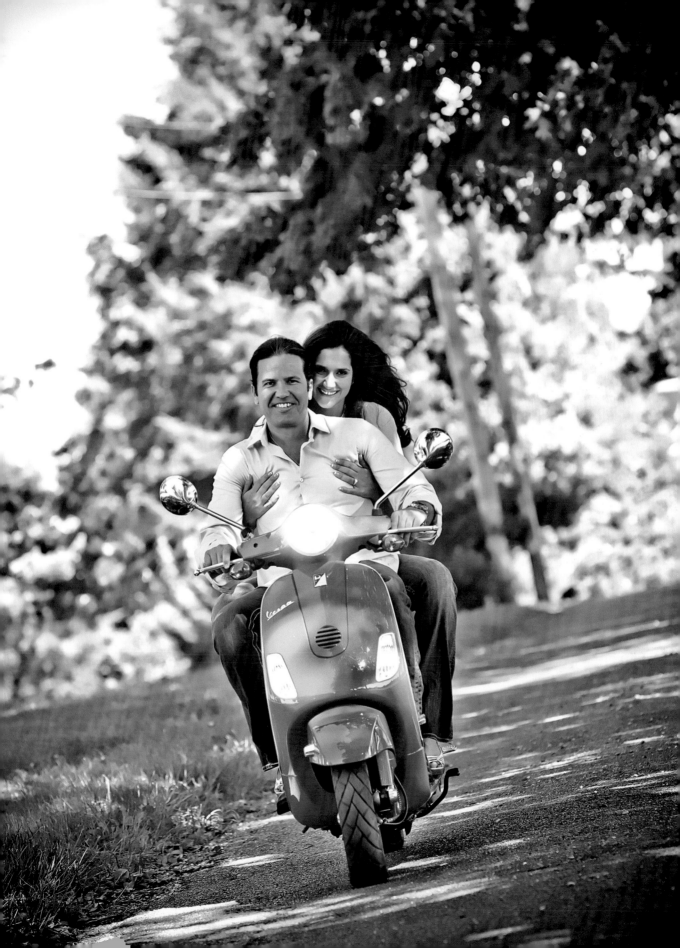

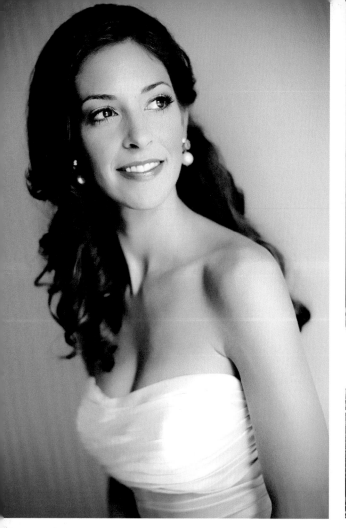

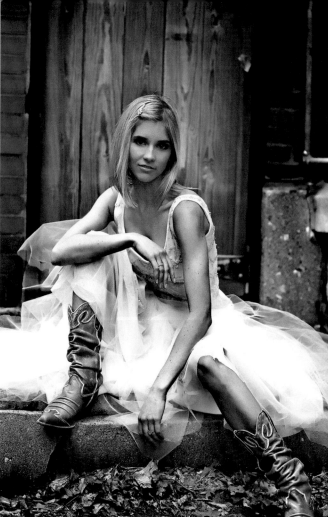

want to buy a couple of 4x6s and a big print for the wall . . . an 8x10 or something," your jaw probably hits the floor—or it should! You have invested 4.5 hours of time and the client just paid less than $100 for it. And, mind you, this doesn't even factor in any costs associated with gear, insurance, or the other various overheads involved in producing the product—let alone a *profit*. You'd be better off working at the mall.

For our engagement sessions, we run about a $1,200 average. How do we get them to that number? It's really simple, actually—and we put no pressure on our clients at all. So, let's walk

through it. We start at $50 for à la carte gift-size prints (again, those are the 4x6-, 5x7-, and 8x10-inch prints). Now, I can hear you all protesting, "There's no way my clients are going to pay that much for a 4x6!" That's great—because you don't want them to. In fact, it drives me crazy when clients *do* pay for items off our à la carte menu.

Instead, we work on a package system and run a low-pressure sales cycle. We do not push our clients and we have no minimum orders. We let them decide what they want to spend based on what products they want and the quality of

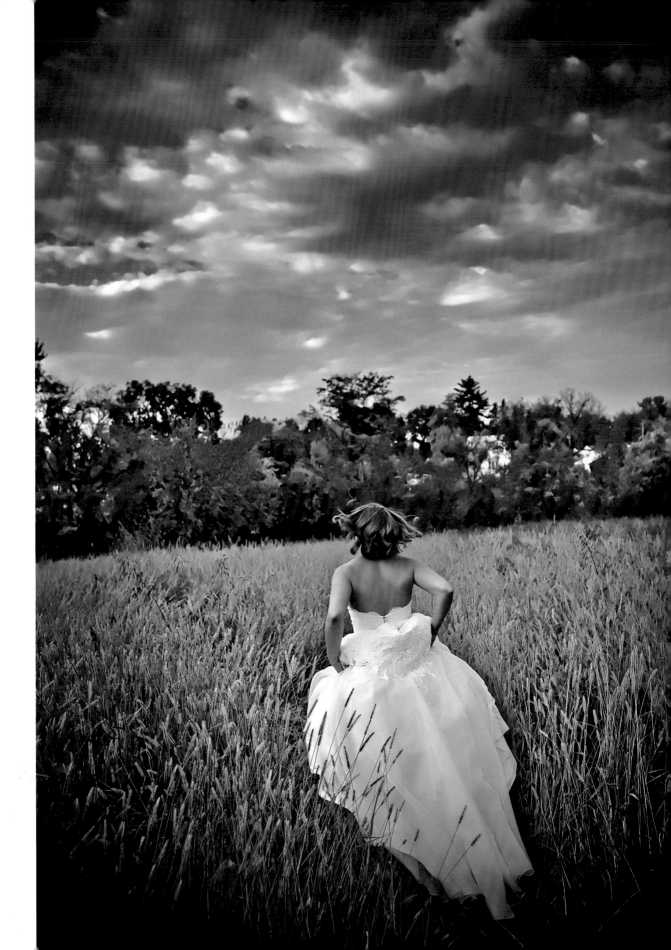

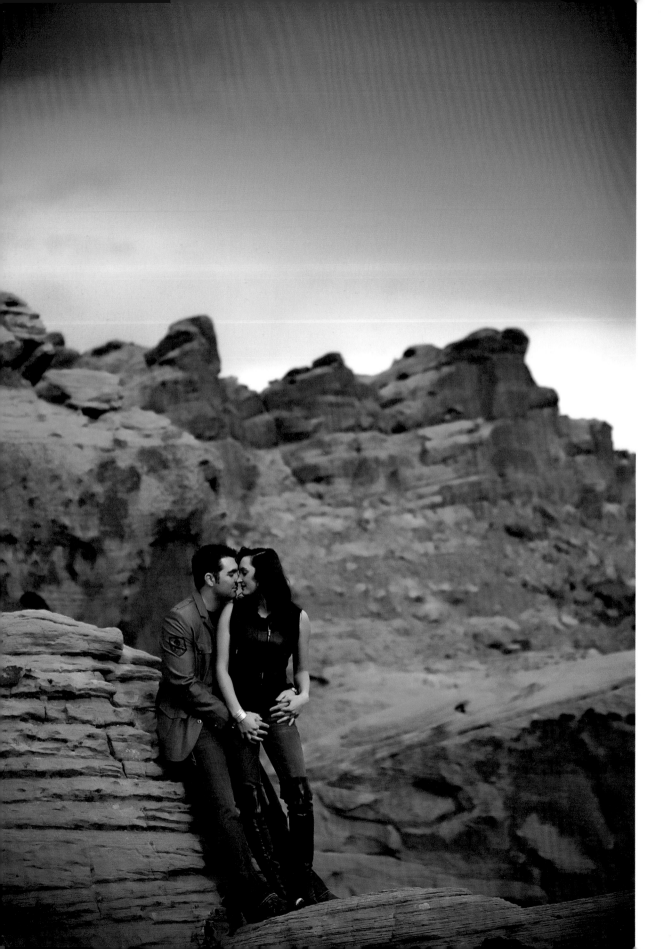

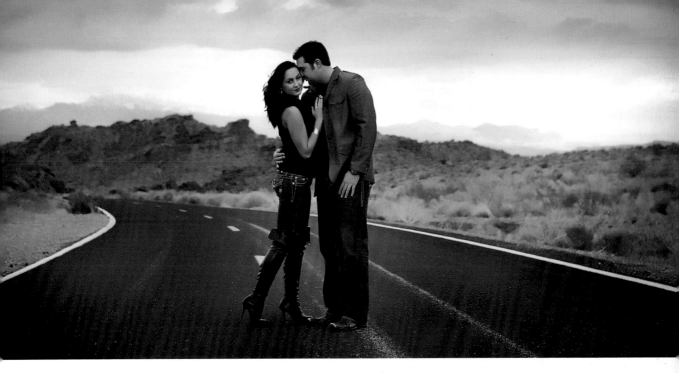

their imagery. They are free to go à la carte, but they are going to pay more if they do. If they go with a package instead, they will see discounts of 20 to 40 percent off the à la carte prices. Starting to get the gist here?

Prices drive consumer behavior. If your à la carte prices are too low, there is no incentive to go with a package. And if they don't go with a package, why would you want to reward them for buying four small prints after you have invested your time and talent for several hours?

RETURN ON INVESTMENT (ROI)

If you are like me at all, you love gadgets and electronic toys. However, funding these sometimes bad habits is another story. So before I run out and buy the latest action sets (or new camera, or printer, or . . .) I have to be able to justify the cost to our business. While there are certain items that I would argue are must-have items (like a camera or fast lenses), there are many other items that are more nice-to-have than must-have.

Your return on investment (or ROI) is really a measure of this—a calculation of how much you get back for every dollar

If your à la carte prices are too low, there is no incentive to go with a package.

you spend on something. Now, I don't want to get all finance-major on you and pull out the scientific calculator, but this is something you need to at least look at before you buy some-

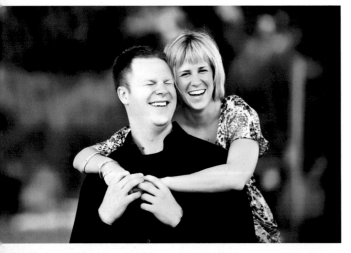

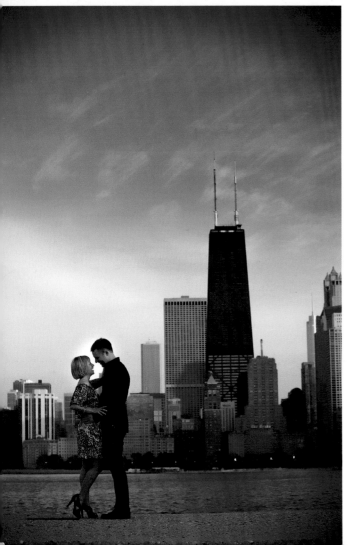

thing. Let's break it down into practical terms and explore a recent scenario I went through before purchasing an Epson 7900 printer.

We spend over $40,000 every year on printing with our labs, not including album production. The majority of this is spent on larger prints—16x24 inches and up. I have no desire, from a time and labor perspective, to sit around printing and trimming 8x10s or smaller prints; there would be too much time involved for there to be any cost justification. For the larger prints, however, it seemed like it would be easy to cut our costs by producing the prints in-house.

The first thing we looked at was the cost of the prints. Today, a 15x30-inch lab print mounted on styrene costs us about $42. That's not too bad—except when compared to the cost of doing it in house, which is less than $15 (including labor, paper, ink, and styrene). That is a huge difference for us because of the large number of prints we do each year. Looking at how many large prints and canvases we produce, we quickly realized we could save over $6,000 per year by printing in-house. At that rate, the printer would pay for itself in less than six months. Our ROI over a two-year window would be about 400 percent—saving us thousands of dollars (not to mention giving us better quality control).

Acquiring the printer also gave us the ability to produce other unique items. For example, we just opened a new studio with eight 9-foot windows. We used the printer to create banners for each of the windows, and my cost was about

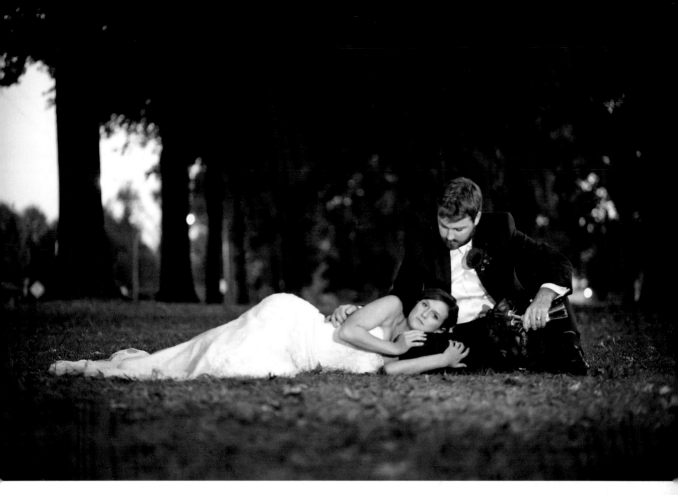

$20 per window. Had we paid a banner company, I would have been looking at about $200 to $250 per window.

So was this a good investment for us? Absolutely! The numbers are huge for us and it gives us all sorts of opportunities to do creative things with our new "toy" (so to speak!). As a rule of thumb, anything I need for the business that can pay for itself in less than twelve months is usually a purchase I am quickly willing to make. If it will take any longer, I am a little more cautious about moving forward.

DO A SWOT DRILL

As any successful businessperson will affirm, you have to continuously reinvent yourself to remain relevant in the marketplace. This sounds good . . . but where do you actually start? As I look around my local market, and I am sure your local market will

> As any successful business-person will affirm, you have to continuously reinvent yourself to remain relevant in the marketplace.

yield the same results, I see a graveyard of once-thriving studios that couldn't remain relevant. They didn't know how. Our industry is so much more than just the imagery. In fact, our imagery is just one facet of what we do. So how do we inventory the current state of affairs and articulate our findings in a way that allows us to take action?

When I was in corporate America, every year we would go through a very simple exercise as a team. We called it the SWOT drill. SWOT stands for Strengths, Weaknesses, Opportunities, and Threats. In this drill, we identify and rank our influence in each of the respective categories. This is a drill that can be as simple or as complex as you make it. The key is ensuring you go through the drill and take action each and every year.

Strengths. In this section, identify five to ten strengths. These are the things that make your business successful. Some examples might include customer service, turn-around time, competitive pricing, etc. If you want, items like customer service can be taken

This is a drill that can be as simple or as complex as you make it.

to a deeper level. What is it about your customer service that makes it your strength?

Weaknesses. In this section, you will identify your top five to ten weaknesses. These are the things that you are doing wrong or doing poorly. You have to be honest with yourself or this exercise is pointless. Let's face it, we all have weaknesses. This should not be a shock to you, so be honest with yourself and use this information to transform your business. Some examples might include slow turn-around time, lackluster editing skills, outdated camera equipment, etc.

Opportunities. In this section, you will identify five to ten opportunities in your area. These are opportunities you know are out there but which you are not currently exploring. For example, maybe you have a lot of children in your community. If that's the case and you are not going after family or children's portraiture contracts, that might be a new opportunity for your business. Don't overanalyze this by getting too far ahead of yourself. For example, don't talk yourself out of going after families before you have had an opportunity to explore it. Another example would be video, which is a new opportunity for all of us.

Threats. In this section, you will identify the top five to ten threats or challenges your business faces. This could be a new studio that opened its doors up the road or the ever-increasing challenges we all face with new technologies. These are items that are hindering your ability to grow your business—or, worse yet, causing erosion in your market share.

Once you have this document together, you can sit with your team (even if your entire team is just you!) and devise a plan of action for the next twelve months. Then, when the year is over, build on your accomplishments by revisiting your SWOT document and creating a new one for the upcoming year. We go through this process every year to guide the future of our studio and objectively look at the outside forces impacting our business.

So is all of this clear as mud? My advice is that you read this chapter several times. Over time, it will start to sink in and you will begin to identify your own metrics for running your business.

2. GETTING THE MOST OUT OF BRIDAL SHOWS

Now you have this wonderful business plan, but how do you get started booking weddings? Bridal shows are the best way to get your work out in front of a lot of brides very quickly. In addition, they allow you to begin networking with your industry peers. However, like all things, you need to have a plan. Just showing up with some prints and an album and expecting a windfall of cash . . . well, that borders on the realm of fantasy. Imagine your toughest job interview, then multiply it by ten. That will put you close to understanding the intensely competitive nature of a bridal show.

I get all sorts of feedback on the effectiveness of bridal shows. If you talk to ten photographers, somehow you'll get ten different opinions on the subject. For us, bridal shows are the source of about 65 percent of our bookings. Yes, we have referrals, but bridal shows allow us to showcase our work to a much wider audience. I love them—I love the energy they bring, and I love being able to create a fan base for our work.

Bridal shows are the best way to get your work out in front of a lot of brides very quickly.

FINDING THE RIGHT SHOW

These days, bridal shows are like gas stations—they are *everywhere*. As a result, to a certain extent brides are getting burned out on them and becoming numb to the hard sell. Therefore, finding the right show is paramount, and defining "right" is equally

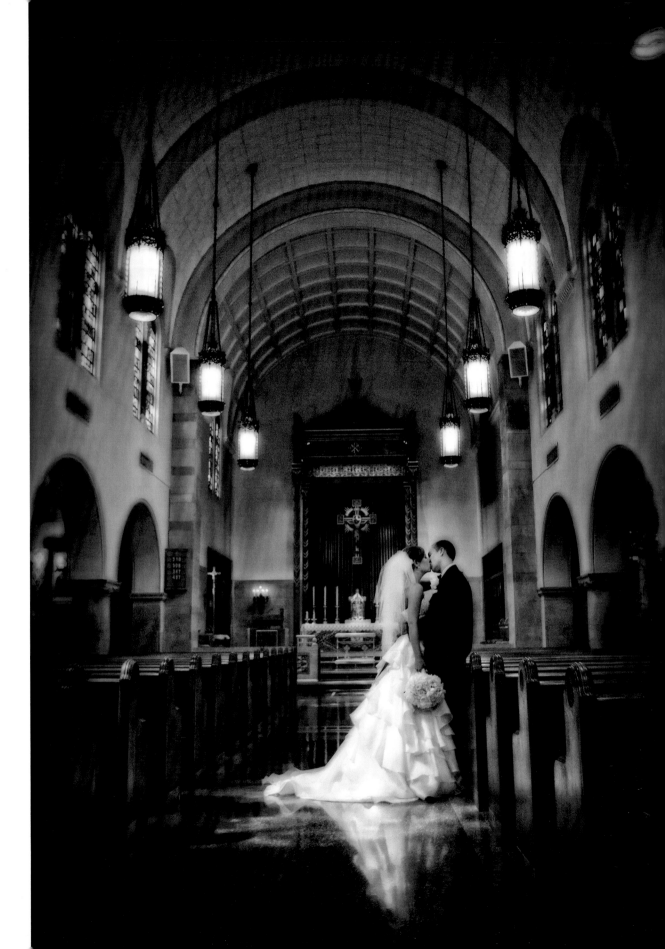

important. Once you understand your target demographic (see chapter 4 for more on this) and price points, you will have a good idea of your target bride. Is she the younger bride or the thirty-something woman? Is she an elite bride spending $100,000 on her wedding or is she more in the mid-range? These are important questions to answer and should be part of your business and marketing plan.

Armed with this information, you will be better able to identify the right show for you. Start by doing a web search for shows in your area. I would be looking at the top ten to fifteen shows. Think about it this way: How are brides finding out about shows? I would bet that the majority of them are searching online. So if *you* can't find the show online, how will *they*? Not every show will have a major web presence, but it certainly helps.

Now, take that list of shows and start reviewing their web sites to see if they have a section for vendors. There, you may find a media kit of sorts. In that media kit, you often have access to very valuable information—in particular, the demographics of their attendees. If not, pick up the phone and call the promoter. They are usually more than willing to talk to you about their show and what to expect.

If all else fails, ask other vendors what they think of the show. Be careful with this approach, though. A vendor's success or failure at these events depends on many factors, including their

How are brides finding out about shows? I would bet that the majority of them are searching online.

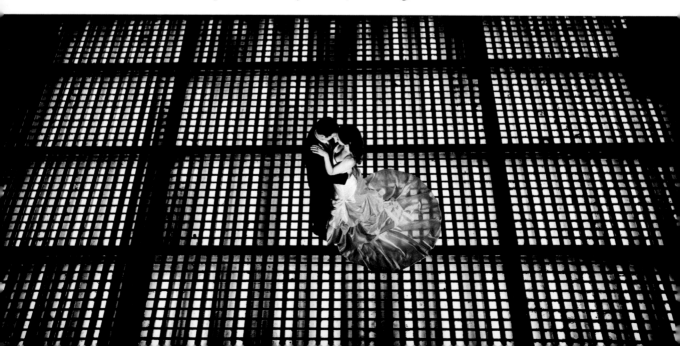

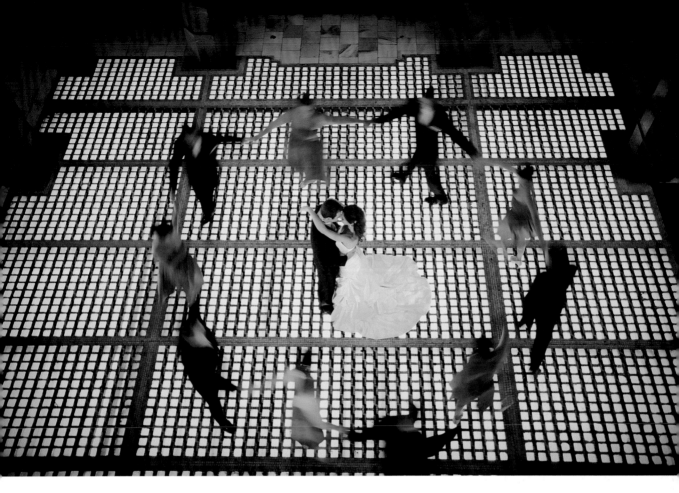

ability to sell themselves and their product. So don't just ask generic questions such as, "Did you like the show?" or "How many events did you book?" Instead, ask more specific and objective questions about how many brides attended, what the caliber of the brides was, etc.

One of the next things I tend to think about is attendance. I have been doing this long enough to know that with so many shows out there, getting the attention of the bride is not easy. And remember that pesky COA number we spoke about in the first chapter? The more brides that attend a show, the better your odds of booking more than one bride, and the better your COA number will be.

Also, how are the promoters advertising the show? Some of the larger shows are tied to a magazine. This is key for me; knowing that the magazine has a certain distribution assures me that the show should have a built-in audience. This is a good sign for sure.

Once you feel confident that the show is attracting the brides you want to book, the next thing to consider will be the price of admission. Not all shows and budgets are created equally. Our first year, we did several of the less expensive shows, and guess what? We booked low-budget, high-maintenance brides. Today, we focus more on the middle market. However, our pricing is on the higher end of the market for

the Midwest. The reason I like to focus on the middle market is because it gives us access to the greatest number of brides. Brides who truly appreciate what we do will be willing to spend more on a photographer. Sure, we love our high-end clientele, but there is nothing more satisfying than working with a client who had to stretch a little to work with you because they love what you do.

In addition, we went from a single booth back in 2007 to a double booth at almost every show today. I love being able to showcase my work in a way that really stands out—and having that double booth really sets us apart from the rest.

GETTING PREPARED

Now that you have decided to participate in the show, the real fun begins. Preparing for a bridal show is never easy. In fact, I will never forget my first bridal show. I was so nervous that we would fail and our work would be rejected that I wanted to pull out the night before (and for anyone who knows me, confidence is *not* something I lack!). I don't know what it was; I just had so much anxiety about the whole thing. My wife, being the amazing supporter that she is, pushed me to stick with it and, sure enough, it was a huge success for us. Within a week, we booked twelve weddings from that show. It was unreal and it opened my eyes to the impact these shows would ultimately have on our business and our future.

Displays and Samples. You have to understand your brides and understand what they are looking for. If they are going to shell out thousands of dollars to work with you, they want your creativity, energy, and artistic talent. And believe it or not, they often make up their minds about you within thirty seconds of setting foot in your booth. The way you dress, the pictures you are showcasing, your sample albums, the look and feel of your booth—these factors are all in play.

We want our clients to lust for our brand. We accomplish this by ensuring that everything we do is of the highest quality. We

If brides are going to shell out thousands of dollars to work with you, they want your creativity, energy, and artistic talent.

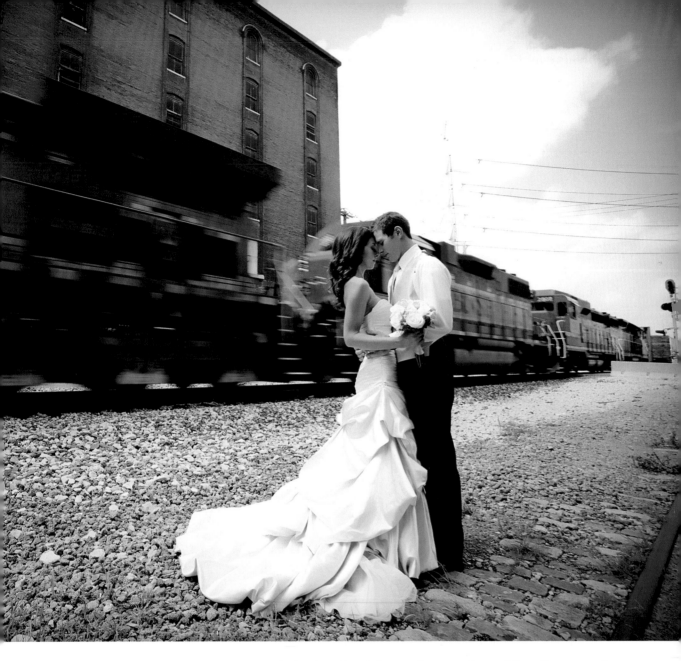

invest in having the right products to show. After all, you can't sell it if you don't show it. Don't underestimate the importance that this will have on your overall success at the shows.

Here's my first bit of advice: don't show up at a bridal show with small prints. Remember, you are a photographer and you sell imagery! Every year, I see a new crop of photographers wanting to make it, and this is the one area where they all seem to fall flat on their faces. My feeling is that small images are something

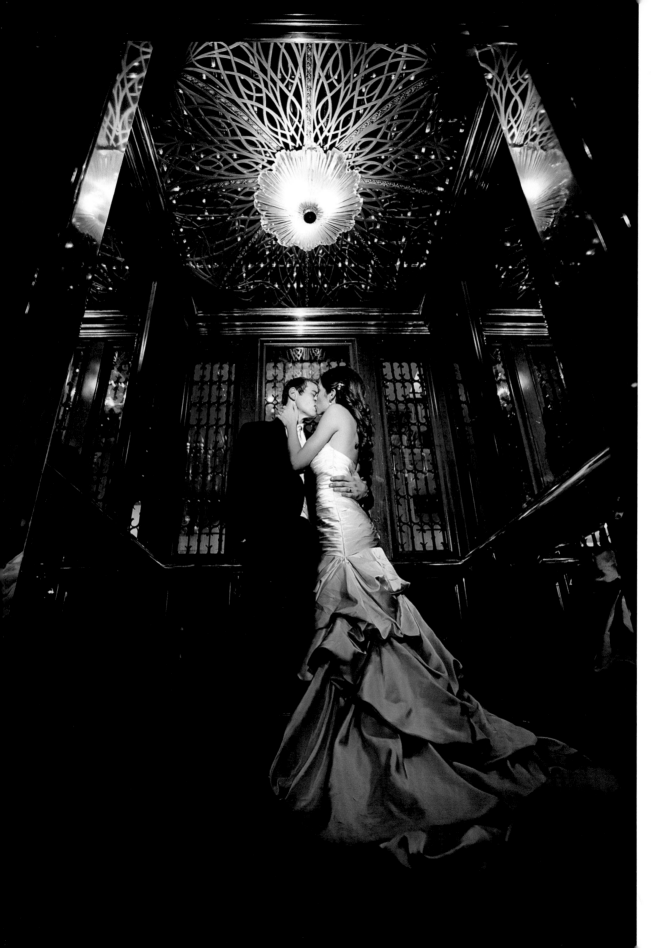

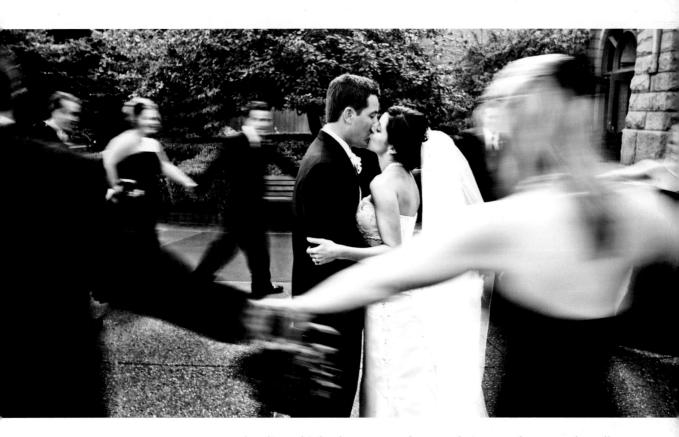

the client thinks they can produce on their own; they regard small prints more as snapshots than professional, high-quality images. Ask yourself: Are you trying to sell small images? Or do you want your potential clients to see you as an artist? Do you want them to fantasize about seeing themselves in one of your masterpieces? I sell vision. I sell art. I sell an experience. And none of that comes in an 8x10-inch package.

So go big! Make a statement and give them something to remember you by. Show them your top five or ten "statement" images—those shots that really get a bride to say, "Wow! I want *that* for my wedding day." Yes, things like detail images are important to showcase in your overall portfolio, but I have never booked a bride who said, "Yep, that's the best shoe photo I have ever seen. This guy is for me!"

Albums are one of the main products through which we differentiate ourselves from the competition. Therefore, we invest a lot of time and energy in ensuring that we have unique styles for

Your displays should feature big images with big impact—shots that make the bride say, "Wow! I want that!"

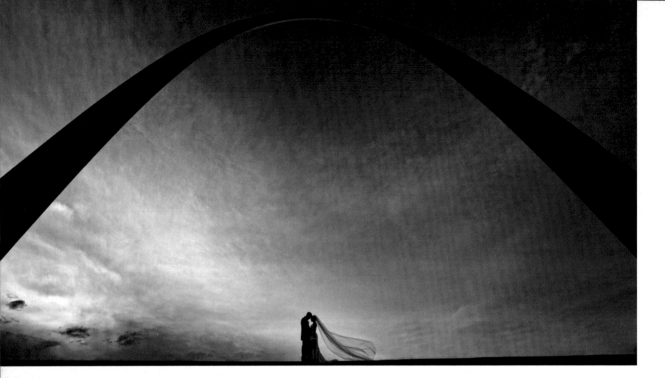

brides to choose from. We carefully select styles that represent our brand and the overall design we are trying to sell. We are a very modern brand, so we strive for simplicity in our album designs—we don't put 150 images in a twenty-page album. Because we don't show albums designed this way, we don't get clients who expect this. If you don't have albums, go and make the investment. If you haven't updated your samples in more than two years, guess what? It's time to bite the bullet and get some new samples. There's really no excuse; almost all album manufacturers make it simple for you to get an updated sample album at a 40 to 50 percent discount.

Your Attire. The last thing I want to cover regarding being prepared is your attire. I know it's a strange thing to discuss in a business book, but the adage is true: you have to dress for success. Brides (at least the ones I'm going after) tend to be very fashion-oriented. If we want them to spend money and care about the way they look in pictures, we need to care how we look, too.

I am not suggesting you dress in a way that is not you. But, again, this is like a job interview. Yes, they are judging you and, yes, it's pretty superficial. Trust me—I understand that our im-

If you haven't updated your samples in more than two years, guess what? It's time to bite the bullet.

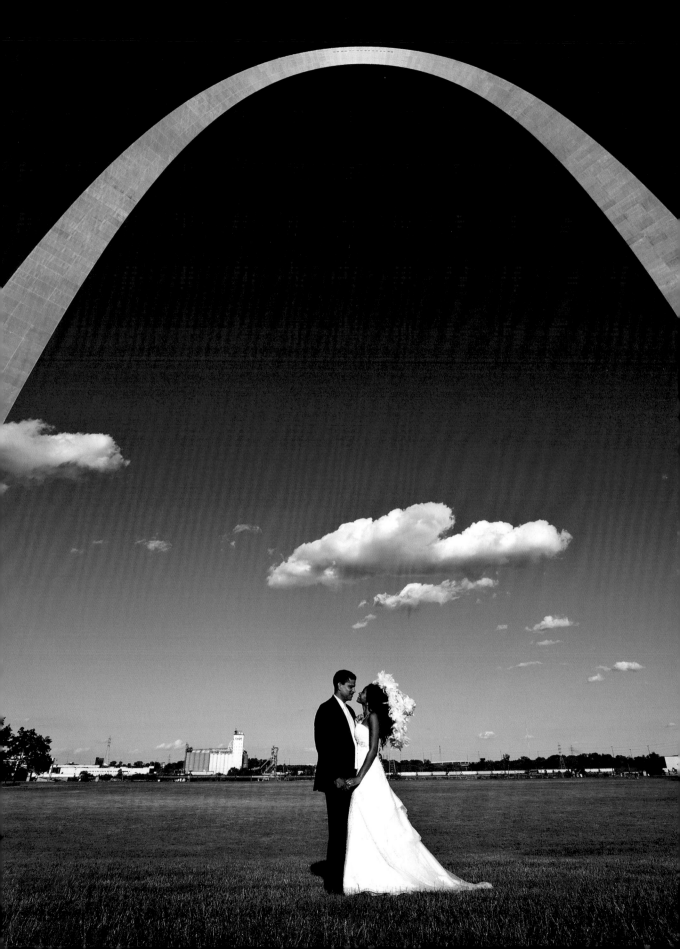

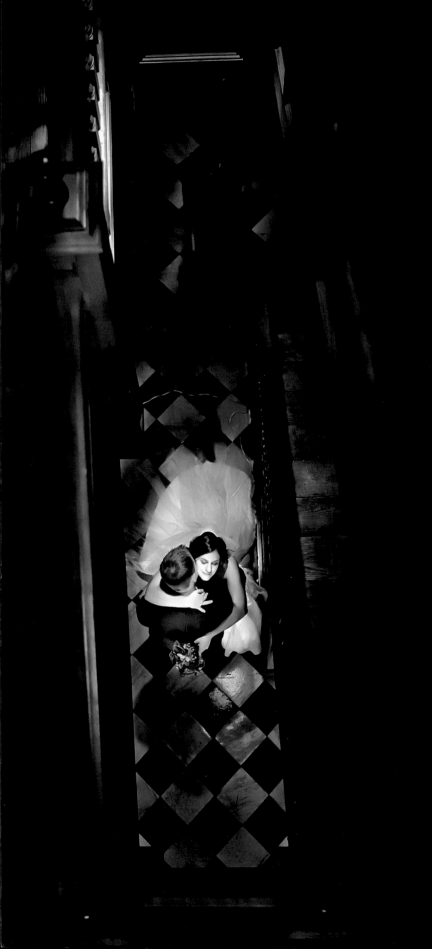

At each bridal show, we are
looking for approximately
ten brides in the sea of
couples—ten brides who
get what we do, ten couples
who identify with our brand
and our style.

agery is not tied to the way we dress. However, this is the world we live in and my goal is to remove any barrier that would prevent a couple from booking us. I want them to be able to relate to us and ultimately book us for their event.

WHAT TO EXPECT

Now that you are ready for the big show, you should have set some goals for yourself. We go into every show with reasonable expectations. At an average show, we want to book about four to five weddings to make the numbers work.

Understand Your Objectives. Going into the show, we know that it's going to be intense, so we ratchet up the energy level. At one of the best shows in our area, there are about 1500 brides in attendance. I know one thing: I don't want to book 1500 weddings. We are looking for approximately ten brides in the sea of couples—ten brides who get what we do, ten couples who identify with our brand and our style. This is a daunting task. We're talking about homing in on less than 1 percent of the brides.

How do I focus in that tightly? I don't. My hope is that all the work I did to prepare my booth will pay off by naturally attracting the right brides. Is that always the case? No, of course not—but it helps for sure. I have no idea who those "right" brides are or what they look like, so we treat every client who walks up like

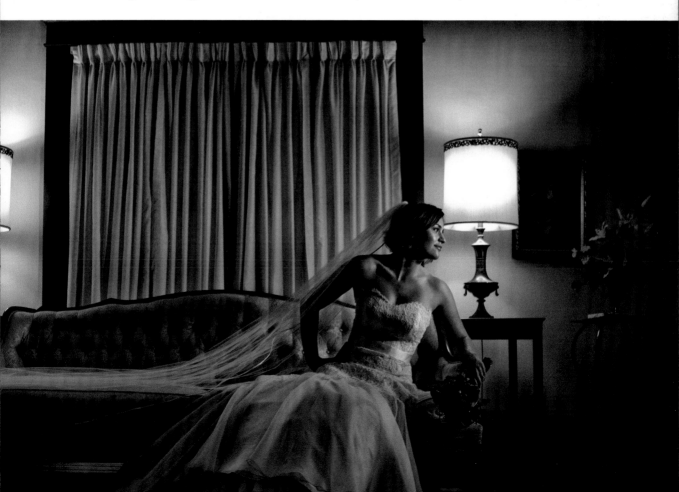

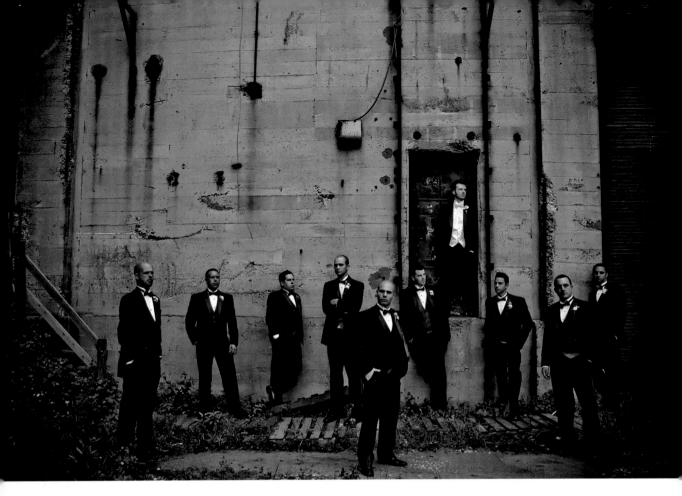

they are the only client there. There are two of us in the booth and we split up to ensure we are connecting with as many people as possible. And trust me when I tell you this: even if you don't get to speak to someone one-on-one, they are hanging around in the background listening to your sales pitch. So make sure it's solid.

Sell Yourself. In general, photographers are not salespeople and tend to be a little more introverted. If this is something you need to work on, be sure to do it. Practice—yes, I said *practice*. Talk to yourself in a mirror if you have to. Listen to yourself deliver your pitch. Does it sound natural or does it come off as rehearsed? Be honest with yourself or ask someone else to listen. Sure, it seems stupid—but I am an author, a lecturer, and an active photographer, and I still talk to myself. (I'm not sure what that says about me, but that's another story.)

I have no idea who those "right" clients are, so we treat everyone who walks up like they are the only client there.

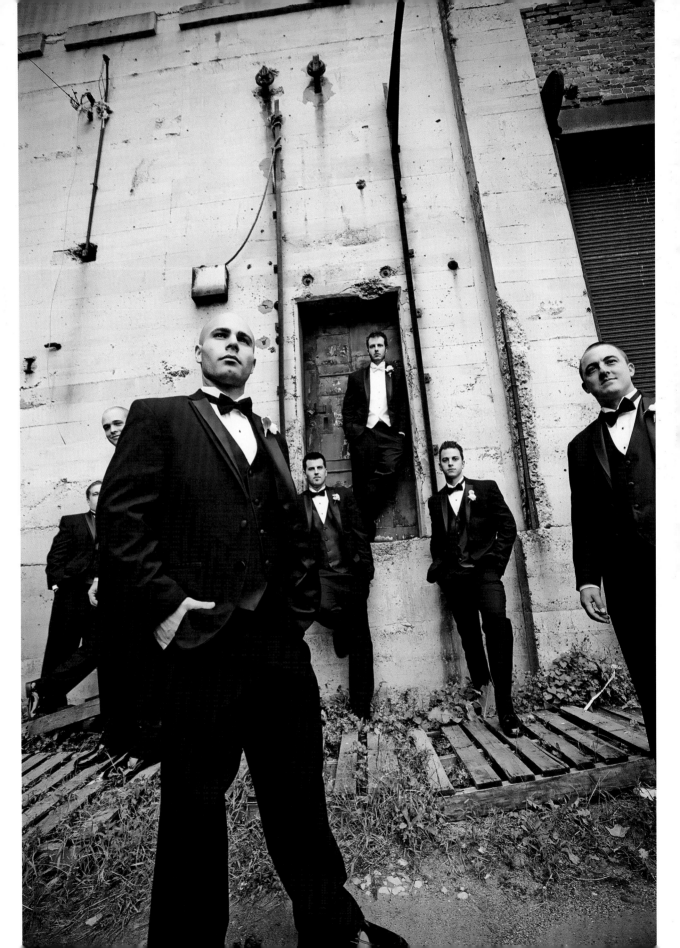

When I am talking about your sales pitch, I am not asking you to be super sales-guy. You just have to be able to present your business effectively to someone in about thirty seconds. You need to tell them why they should choose you and what makes you different from every other photographer in the room. While no one may ask you those questions directly, you can bet that's what it comes down to, so be sure your pitch clearly communicates your value proposition. (And now we have a new term: value proposition. This is a term used to describe the unique benefits you offer to prospective clients.)

Provide an Incentive. At some bridal shows, we like to collect names. To entice the brides to register, we have an item we are raffling off. It could be a free engagement session, a slide show, or some other product. Generally, brides are more than willing to give you this information—and some even come prepared with sticky labels that have all their information printed on them.

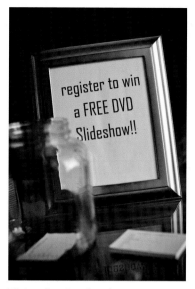

The collection bowl we use to gather names at the bridal shows.

We have a big glass bowl and a sign-up pad where people can leave their information. This information is a gold mine for leads. We typically collect 150 to 300 names from a good show. We then use these leads to send out an e-mail blast to everyone who stopped by our booth. This keeps us fresh in their minds and usually generates another four to six meetings with brides.

JUMP IN!

Now, let's get those fingers typing. Check for bridal shows in your local area and get ready to jump in with both feet. The first show will be your toughest, but if you invest the required time and money and do your homework, you will be well on your way to finding success in the wedding industry.

Check for bridal shows in your area and get ready to jump in with both feet.

3. MARKETING TO BRIDES

Facebook, Twitter, MySpace, YouTube, blogging, direct mail—it's enough to make your head spin. And of course, we always have to be on the lookout for the next big social media experiment. It can be overwhelming at times. And without a plan of attack, it will quickly become unmanageable. These are all tools available to you in marketing your business. However, the key with any tool is using it (or them) to make your job easier and to increase your productivity.

The goal of this chapter is to discuss the things we do in our studio to be successful. It is not meant as an exhaustive list by any means. For us, the following tools have been integral to achieving success.

> The key with any tool is using it to make your job easier and to increase your productivity.

FACEBOOK

In my opinion, Facebook is currently the most important social networking site and an important way of connecting with our fan base. Our brides are plugged into our profile and know that this is the place to check if they want to see what we're up to. We try to keep this as up-to-date as possible, constantly posting new images and regularly connecting with our clients.

In particular, I am a huge proponent of using images; after all, we are photographers. I can post words all day long, but people don't want to hear me talk about the weather, what I had for din-

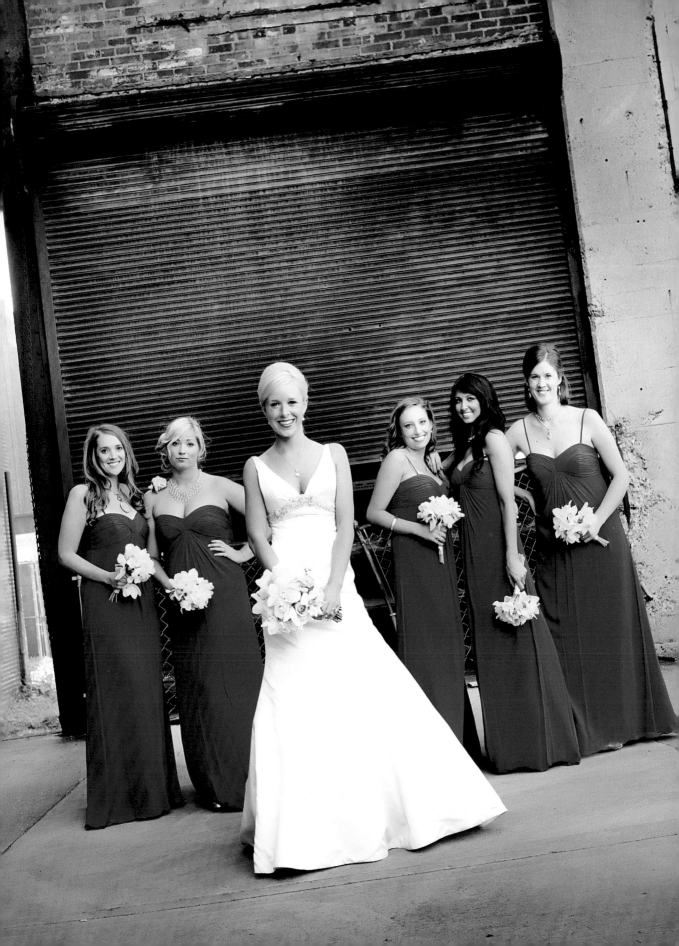

ner, or the meaning of life. So, I post pictures—and lots of them! Additionally, clients love to tag themselves in Facebook images, which has a been huge asset for us. Through tagging, you can get your images in front of lots of new people *without* having to drive them to your personal web site. Once your clients tag themselves, the images spread like wildfire for all their friends to see and comment on.

Another great use for Facebook is to post specials you are currently running at the studio. If you have a large enough fan base,

Once your clients tag themselves in a Facebook photo, the images spread like wildfire for all their friends to see.

they will even help promote the specials for you. This is a great referral engine.

Mutiple Clients, Multiple Sites. Now, I would be remiss if I didn't warn against combining your personal and professional sites and contacts. In my mind, this is a huge misstep. I have been shocked to see some photographers using their personal Facebook page as their business page—with disastrous results. One professional photographer I saw had pictures of herself out partying and drinking. Another I saw had pictures of her in a bikini posing at a local chicken-wing restaurant. I am not the most conservative person in the world, but I see this as being in bad taste. You have to use common sense; you don't want to lose

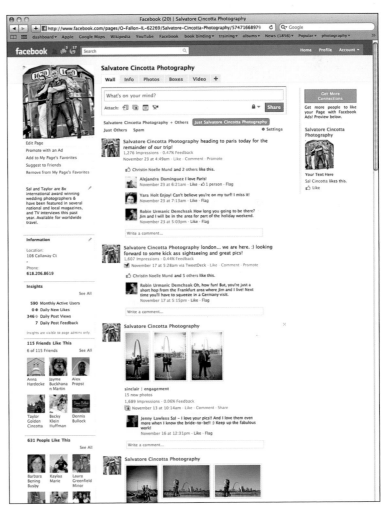

RIGHT—We have several different Facebook sites, each aimed at a specific category of people.

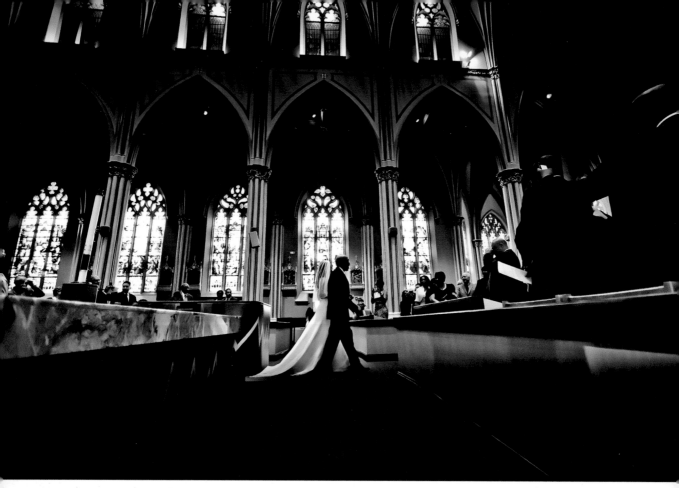

any type of client because of something they see online. Just as religion and politics don't always mix with business, booze and bikinis are clearly on the no-no list.

I have four separate Facebook sites. One is a personal site where I allow all my friends to connect with me and a few select clients. Even on this site, my postings are very conservative. The rest are strictly business sites. One is for BehindTheShutter.com (a site for professional photographers), another for high school seniors, and the final one for the main studio.

My thoughts on this are simple: brides don't want to sort through all my senior pictures, nor do seniors want to wade through all my wedding images to find their friends' pictures. And, of course, I don't want my clients seeing my personal pictures or other personal information. The best thing to do is just use common sense and think about who will be seeing what you

Brides don't want to sort through all my senior pictures, nor do seniors want to wade through all my wedding images to find their friends' pictures.

post. You don't want the mother of the bride seeing you do keg stands at a Halloween party.

Don't Rely on Facebook Exclusively. Now, don't go getting all crazy on me and thinking, "Sal, this is amazing! I can stop going to bridal shows and just use Facebook!" Um . . . no. That's not what I'm saying at all. Facebook is an amazing tool, but it's not a Swiss army knife. It's just *one* of the important marketing tools in your arsenal. You should never, ever abandon tried-and-true methods of reaching your target market. All you have to do is look at the major international companies for some guidance. (Which, by the way, coming from corporate America, is something I do all the time.) These companies have spent billions of dollars working through all sorts of marketing and advertising issues. It would be foolish to ignore the valuable lessons they can teach us; understanding their mistakes saves me lots of time and, more importantly, lots of money. Looking to the big companies

You should never, ever abandon tried-and-true methods of reaching your target market.

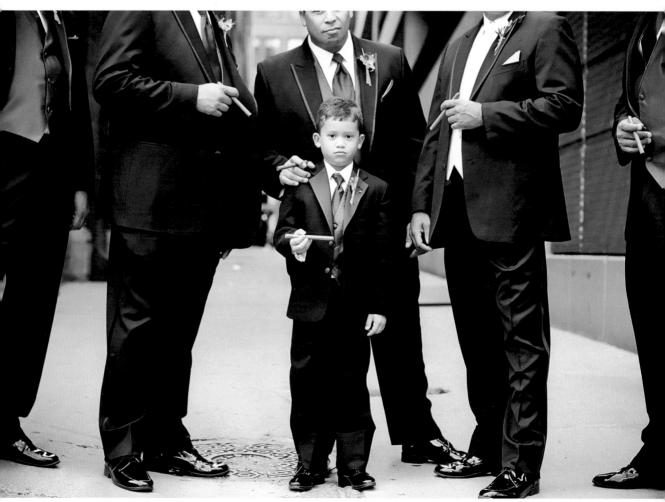

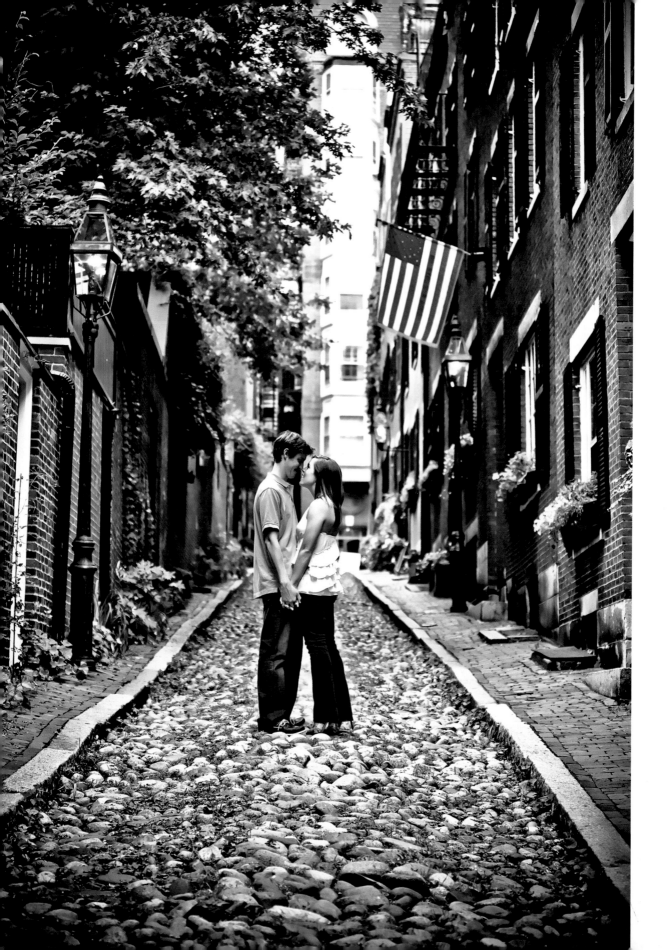

for guidance, you will see that they are using Facebook and other social outlets to *comple-ment* their core marketing and advertising efforts, not to replace them. That's the approach photographers should take as well.

TWITTER

I have to admit, I resisted Twitter for the longest time—I just didn't get it . . . and I'm not 100 percent sure I get it now. But with all the technology to link from Twitter to Facebook and back again, I have become a fan.

Twitter is more about messaging (messages are called "tweets") and less about images, which is fine. It's all in how you use it to get your message out. I like to use it to notify my followers that we have posted new pictures. From time to time, I will tweet something I am doing or working on, but I really like to use Twitter to hit an extended audience.

Again, it's another tool in the toolbox and you need to understand how it can help you reach people. There are some great (and free!) tools on the market that enable you to connect this information into one place—a dashboard, really. Check out a tool I love called TweetDeck, which gives you access to all your Facebook sites and Twitter information in one place. Genius!

BLOGGING

Another very powerful tool is your blog. Blogs are free for the taking, with free templates ga-

BELOW AND FACING PAGE—Blogs are an easy-to-update complement to your web site, allowing you to showcase new images immediately—which is always exciting for clients.

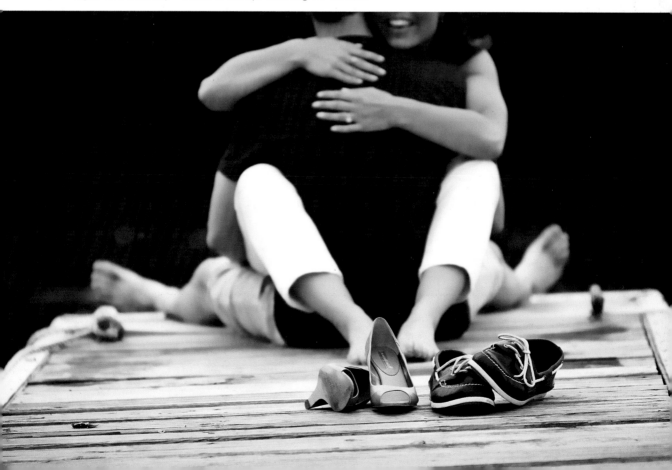

lore online. You can set up your free blog in a matter of minutes at sites like Wordpress.com and Blogger.com. What I particularly like about my blog is the ability to keep it branded with the rest of our sites. This is something that is lost with Facebook, Twitter, MySpace, etc.

Again, there are tools that easily allow you to keep your blog in sync with your Facebook and Twitter accounts. Something new I am going out of my way to use, as of this writing, is a new plug-in that allows you to grab your pictures straight from Lightroom and send them to your blog correctly sized and with your logo on them. Brilliant! Any tool that can save me ten or fifteen minutes at the computer is a tool I take a serious look at. Before I started using it, I was using all sorts of workarounds to get my images

sized, exported, branded, and then uploaded to the various sites; it was a time-waster to say the least.

Look for efficiency boosters wherever you can find them. They will save you both time and money—and maybe even your hair!

YOUR WEB SITE

Today, web sites are an absolute must! If you are looking to connect with couples, you need a web site to showcase your work. Nothing screams "Unprofessional!" like not having a web site. Fortunately, there are plenty of companies out there that make it easy for photographers to get online in minutes. If you don't have much of a budget up front, use one of the many photography template sites out there.

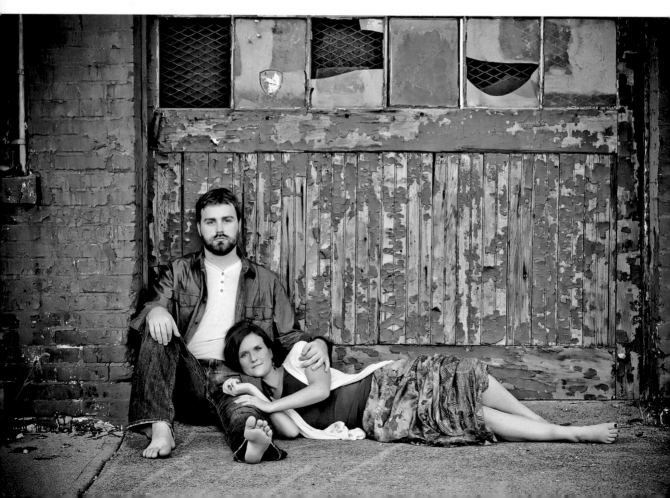

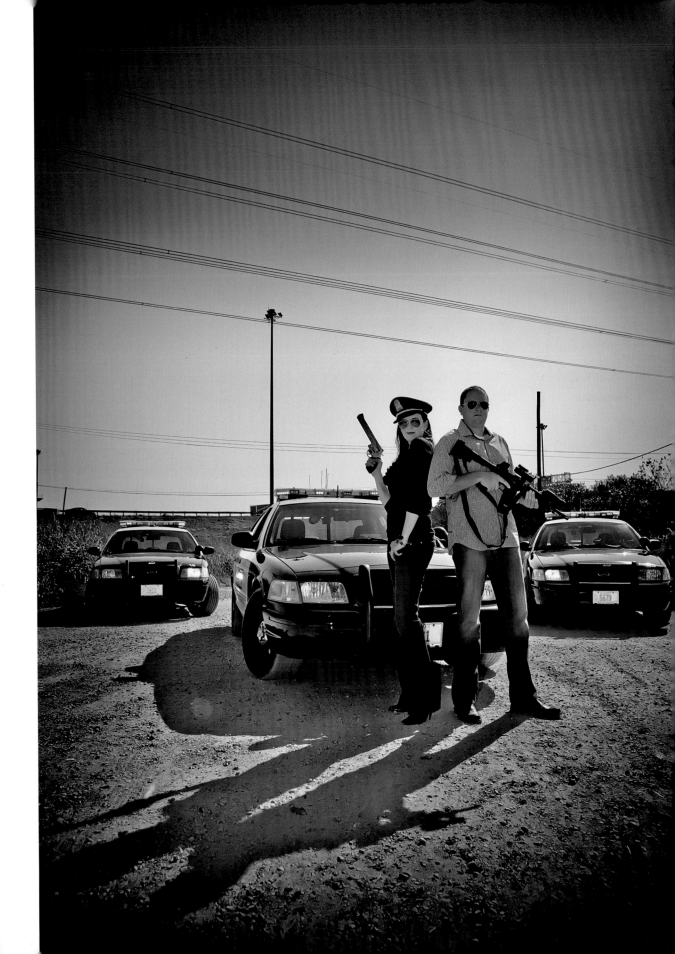

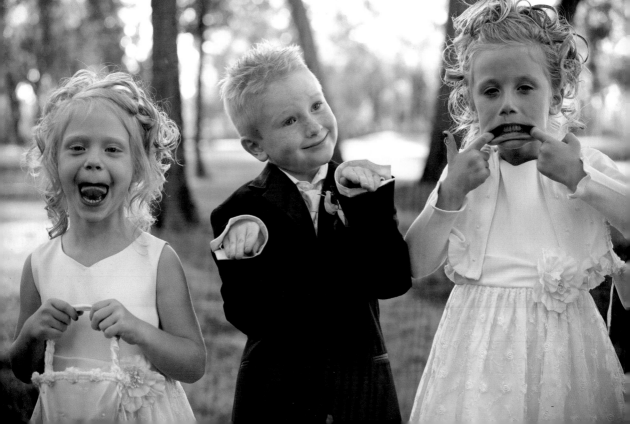

And once you have the budget, I would recommend launching a custom web site immediately. It's well worth your time and energy to get this part of your business up and running correctly.

A Cohesive Look. As you're building your web site, be sure to keep it in line with the overall look and feel of your brand (we'll look at this in more detail in chapter 4). The colors, logos, navigation, and copy all need to present a cohesive impression to viewers. To me, this is a very easy thing to get right—yet so many new businesses get it very wrong. Why is it so important to be consistent? Because all of these elements work together to define your brand. People who come to your site should immediately get a sense of what you're about and the quality you offer.

An Integrated Blog. You want a blog that integrates directly with your site—and by "integrate," I mean it looks like it's part of your site, not like the visitor is being redirected to a third-party site. This is not overly expensive to do, and it's an important part of your custom site. (Visuallure.com was directly responsible for our web site and blog integration, so I recommend checking them out.)

Easy Navigation. Everyone who visits your site should be able to easily find the information they need—whether they want to see wedding image samples, find your phone number, check your blog for the latest news, or read about your qualifications. If you make it difficult for users to get to the information they are looking for, they will quickly move on.

ABOVE AND FACING PAGE—From heartwarming humor to captivating romance, the images on your site should let visitors quickly see what you're about.

Keep It Relevant and Current. Closely tied to helping users find the information they are looking for is ensuring that the information they *do* find is relevant. Keeping our web site up to date is one of the biggest challenges most of us face—and most of us are guilty of failing to do so. And it's not because we don't have great images we are working on, it's just that we just don't make the time to post them. Remember

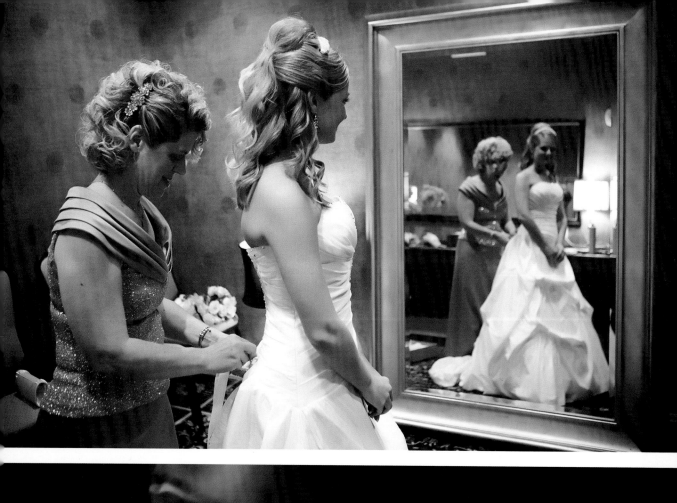

ABOVE AND FACING PAGE—I want everyone who visits my web site to see lots and lots of pictures. After all, that's the nut of what we offer: great imagery.

back in chapter 1 how we talked about identifying weaknesses (part of the SWOT drill) in your business and making a plan for improvement? Well, one of my goals for the upcoming year is to enhance our web site, making it as easy as possible for us to update it on a bimonthly basis.

Show Lots of Your Best Photographs. Most importantly, I want everyone who visits my web site to see lots and lots of pictures. After all, that's the nut of what we offer: great imagery. I think it is very important to showcase our best images. I don't know about you, but I am a better photographer today than I was yesterday. I want my online portfolio to showcase that—and to remain in step with the current trends and fashions.

THE REST OF THE ONLINE WORLD

This is my personal opinion, but I don't find a lot of use for a majority of the other sites. There are all sorts of options out there,

but they are not worth the effort. We've found that Facebook, Twitter, and blogging keep the phone ringing. If, down the road, something replaces Facebook as the leading social networking site, we will stay current with our clients and ensure we are putting our work where they will find it.

The main takeaway here is this: you have to experiment. Find what works for you and your business. If it doesn't work, move on. Don't get married to any one medium because, before you know it, people will be moving on to the next one. If you pay attention and stay plugged in to your demographic you will have no trouble staying relevant.

THIS PAGE AND FACING PAGE—After every event, I send key vendors (florists, caterers, etc.) images of their great products and services.

VENDOR DISPLAYS

We have spent a significant portion of this chapter talking about your online efforts, but there are other options you may not have thought about. These options, in my opinion, are just as powerful as (and more measurable than) your web presence.

After every event, I send key vendors (florists, caterers, etc.) images of their great products and services. If they request digital images, I send them digital files with my logo on them. Otherwise, I send a mid-sized print with my logo on it—and maybe a collage of images from the wedding. Why? The answer is simple. It's huge exposure for us. These images end up being displayed in the vendor's place of business and at any bridal shows they attend. This is great publicity for the studio; as brides walk around the bridal show, they will see your information over and over again. The cost of a print is nothing compared to the exposure this will bring. I'm also thrilled when a vendor loves our images so much that they use them on their web site—or, even better, when they use an image for their print ad and our logo or copyright information is tied to the image. Again, you cannot beat this kind of publicity.

Vendors display our images at their places of business, show them at bridal shows, and even use them in print ads. You can't beat that kind of publicity.

Every year, I try to get better and better at sharing our images with vendors. It's a win-win situation. Recently, a new site called Two Bright Lights (www.twobrightlights.com) has promised to make it easier for us to share images with vendors and magazines. Time will tell how easy it really is. I have recently joined the site and look forward to more efficiencies. I suggest checking the site out to see if you can make it work for you.

PRINTED PIECES

While I am a big believer in direct mail, I don't believe it works well for wedding prospects. It's very expensive and it's very difficult to connect with your desired demographic. However, I am a huge believer in putting something in brides' hands that they can see and touch. We produce a high-quality, eight-page flyer that we leave at various reception halls around town. Using this approach, I feel as though we are hitting more of our target audience—brides who are considering holding their weddings at the venues we love to work in. I can also safely assume that brides

> While I am a big believer in direct mail, I don't believe it works well for wedding prospects.

who pick them up don't already have a photographer. (I know, I said "assume" . . . but it does seem like a better bet than the alternative, which is a direct mailing to couples who may or may not have a photographer and may or may not be in your demographic.) We have seen a lot of success with this strategy.

FINAL THOUGHTS

And there you have it—the secret to our success. As you can see, it's not overly complicated, but, yes, it's very involved. We put a lot of work into ensuring that we are constantly in the hearts and minds of our couples and the vendor community that has the power of referrals. We want them to know we exist, to be fans of our work, and to make it easy for them to work with us.

So find the plan that works for you and keep refining it until it's performing like a well-oiled machine. And then, just when you figure it out, get ready for it to change!

We put a lot of work into ensuring that we are constantly in the hearts and minds of our couples.

4. DIFFERENTIATING YOURSELF

Once you understand your demographic, it's easy to establish a brand and marketing plan.

If you think that you, as the artist, are in charge of defining "cool," think again. There are multibillion dollar corporations spending millions and millions of dollars to capture the attention of the elusive and finicky 18- to 24-year-old demographic. And while this might not be your target market today, this demographic will soon graduate, enter the workforce, and become your brides and grooms-to-be.

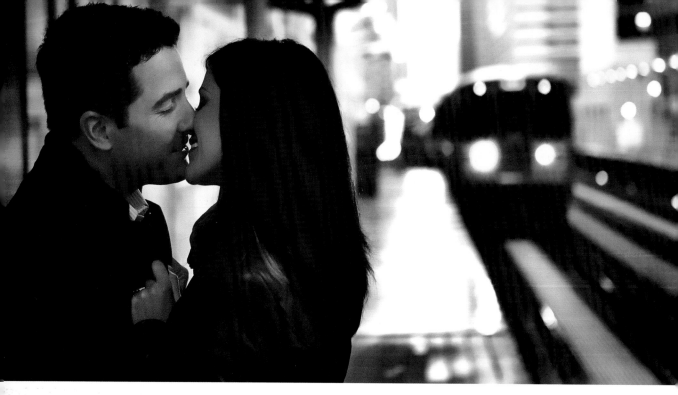

So how do we, as small businesses, plug into this demographic? Follow the leader! Once you understand your demographic, it's easy to establish a brand and marketing plan targeted at their needs. And make no mistake: this is about the bride and groom, *not* you or your studio. I have seen artists all over the country "being true to their art" and that is wonderful. However, at the end of the day, we are running businesses and the goal of any business is to make a profit. In order to do that, we need to remain relevant by adapting to our market.

IDENTIFY YOUR TARGET

The first thing you need to do is identify your target. At first, this might sound easier than it really is. Let me guess—your target market is "couples getting married"? Of course your target (the target of *every* wedding photographer, for that matter) is engaged couples. But let's dig a little deeper. Ideally, we all want the trendy, fit, wealthy couples. Those are the couples with the money to spend on photography, and their portraits will make amazing images for your portfolio.

The first thing you need to do is identify your target. At first, this might sound easier than it really is.

The reality, however, is that this part of the market is saturated and very difficult to compete in. As a result, this is not my personal target at all. Instead, we target the first-time weddings of moderately trendy, upper-middle-class couples who place a significant amount of value and importance on imagery. That's my ideal couple. Do we always book the ideal client? No, not at all. However, 85 percent of the time we do—and over the years, we have gotten better and better at sniffing out the ones who don't fall into this group. When we spot them, we politely pass on their event.

I can hear it now: "What? You *don't* book someone who wants to spend money with you?" That's correct. I believe that any business or person operating out of desperation will ultimately fail. There is no event we need so badly that we are willing to compromise our reputation to get it. This is not even a question of being true to our art; it's about ensuring there is a match between the client and our studio. Ultimately, if there is a mismatch, the client will be extremely unhappy. This, in turn, will create a customer-satisfaction issue that can have far-reaching negative consequences for the business.

For us, the main mismatch we see comes in the form of a client just looking to book *any* photographer. Hearing the prospective client say that "you are good and came highly recommended" is a great start, but there needs to be some back-and-forth

discussion before you accept the booking. I always ask certain questions, including:

- Have you seen our web site?
- What about our style jumps out at you?
- Are there certain types of images you have seen from us you like?

If they can list a couple of favorites, we might start talking about these images, how they were created, etc. This gives me a great indication of whether they are just looking for "any" photographer or are really diggin' our work in particular. Basically, I am trying to discern what type of

client I am dealing with. Are they going to let me do my thing and give me the time I need to do it? Or are they just looking for someone to take pictures? It's the difference between being the creative director of their day or some guy with a camera. If there's a fundamental mismatch in our objectives, there's little chance that either of us will be satisfied with the outcome.

THE IMPORTANCE OF BRANDING

Now that we have spent some time discussing our demographic, the next thing we need to focus on is creating a brand that resonates with our desired clients.

First, what is a brand? It is the overall identity of your business, product, or service. An effective brand is a unique, appealing, and consistent theme that runs through your name, the color combinations you use, any tag line you employ, your logo, and every other aspect of your business that clients see. As a photographer, your brand is also comprised of your personal identity and the imagery you produce.

> If there's a fundamental mismatch in our objectives, there's little chance that either of us will be satisfied with the outcome.

Branding is an extremely important exercise you must partake in. Again, this is an area where I see a lot of artists missing the boat. They choose a name, launch a spiffy web site, and—bam!—they're in business. This is the worst possible thing you could do for yourself or your business.

Instead of rushing into the marketplace, take some time to formulate an effective brand and business identity.

Instead of rushing into the marketplace, take some time to formulate an effective brand and business identity. Who are you targeting? What is the feel you are looking to create? Are you looking for more volume or do you want reach more of a niche market?

If you're trying to connect with a particular niche, you need to define that niche and understand everything about it in order to create a brand identity that will attract people from it. Do your research and make sure your identity resonates with your target market.

YOUR LOGO

Once you have fleshed out some of the details around your demographic, it's time to start putting together your logo. For us, this was a relatively simple exercise to go though. First, and foremost, I suggest working with a professional on this project. We work with a company named Visual Lure (www.visuallure.com); they are responsible for all our branding and are amazing at what they do.

Creating a logo is not that expensive—and considering that it will be a part of everything you do, it's well worth the investment. When working with a graphic designer, I suggest giving him a few words to work from. These are the key words that de-

Here are some samples of logos created for us by Visual Lure. As you can see, they present a professional and cohesive look and feel for our brand.

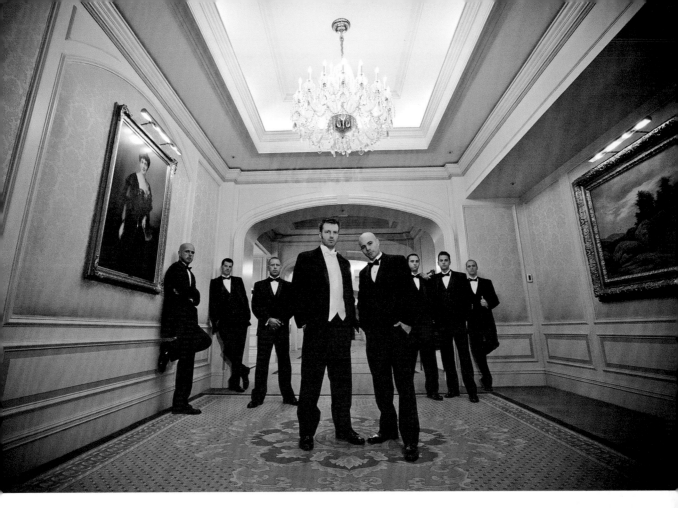

In my opinion, your logo

is a huge part of your

branding effort.

scribe your business and your brand. Are you traditional, modern, or whimsical? For us, the key inspiration words were "creative," "stylish," and "award-winning." From there, your designer, like any artist, should be able to go off and do their thing.

In my opinion, your logo is a huge part of your branding effort. It should evoke a certain emotion when people see it. It should immediately communicate something important about your business—quality, creativity, or any other adjectives you want to throw in there. If you think about it, companies like Coca-Cola have spent a tremendous amount of money to establish their brand. From their jingles to the multinational translation of their logo, anywhere in the world you find a can of Coca-Cola or see an ad for their product, it will look pretty much the same. Now that's taking branding to a whole new level.

ADDING SUB-BRANDS

Closely related to branding is the concept of a sub-brand. This might not be for everyone, but it's an important concept to understand. At our studio, we offer video, wedding photography, baby photography, senior portraiture, and more. Sure, I could have rolled them all up under the main Salvatore Cincotta Photography brand. However, my wedding clients have significantly different needs and tastes than my high-school seniors. It would be difficult to create a brand identity that resonated equally well with both groups.

Instead of trying to reach all of our diverse clients with one message, we have created customized sub-brands that all complement the identity of our main business. This gives us the flexibility to specifically target different clients with different marketing materials. We can even create sub-sites on our web site if we choose to do so. When we are marketing and using direct mail, we can incorporate these new logos and create a deeper brand awareness and loyalty toward our offerings.

Don't get too hung up on this concept, though. When you are first starting out, this may not be much of a priority for your business. However, as you grow and create new lines of business, you need to come back to this concept and see if it is a fit for you.

CONNECTING WITH YOUR TARGET DEMOGRAPHIC

All this talk about branding should naturally lead us to some basic questions about how we can better connect with our target

Our sub-brands offer a unique identity for our separate lines of business but remain in harmony with our overall brand identity.

demographic. Sure, I know who my target is in terms of numbers (their age, income, etc.), but do I really *understand* them? Can I relate to them? And more to the point, can they relate to *me*?

Understanding your target demographic requires you to understand how they work, live, socialize, dress, etc. I have found that if you start doing some of the things they do, relating to them becomes very easy.

What to Watch. Let's start by figuring out what they watch. This is pretty easy, really; just watch some prime-time television and let the networks do all the work for you. Or turn to the cable networks for a slew of reality shows and punch lines that become part of our popular culture. I'm not a big TV fan—I work way

> Understanding your target demographic requires you to understand how they work, live, socialize, dress, and more.

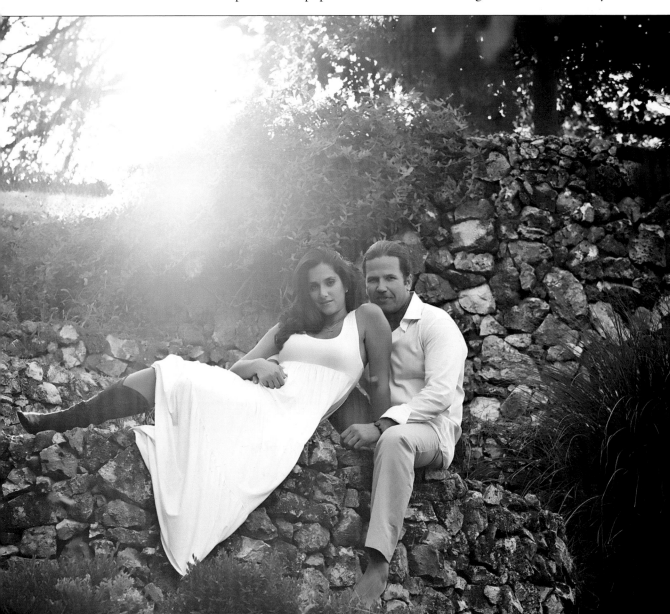

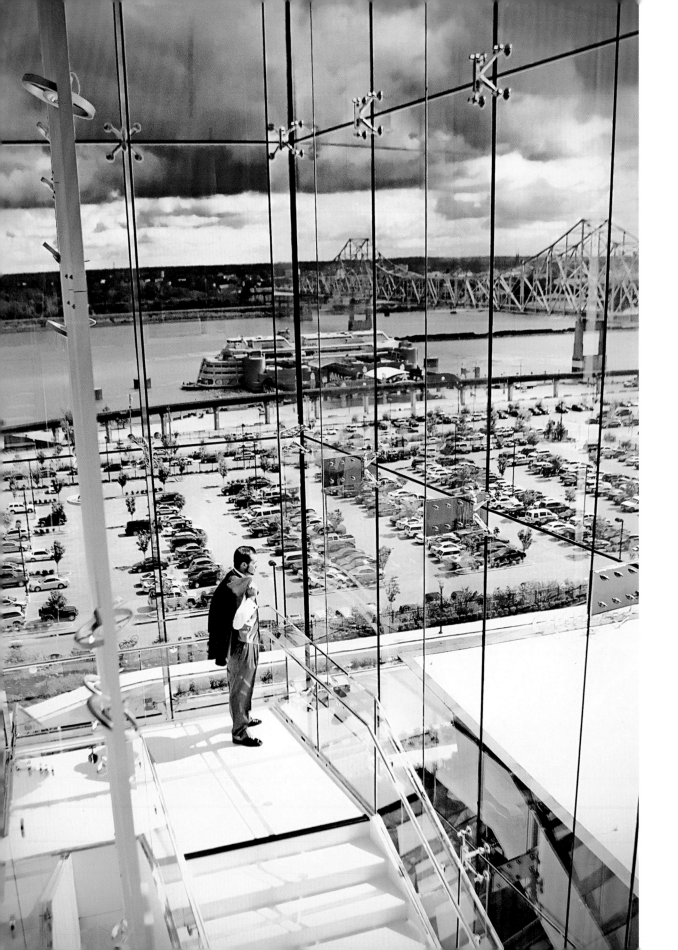

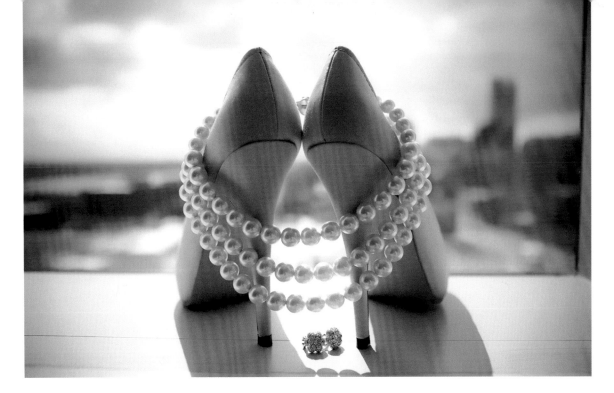

too much to have time to sit and watch it—but it is an important way to plug into and understand your demographic. (And I have to admit, even I get hooked on some bad television from time to time. It's addictive for sure.)

What to Read. An area I do spend some time on is reading magazines. It's not uncommon to find me sitting in a bookstore flipping through all sorts of magazines—from bridal magazines, to tattoo magazines, to European magazines. In addition to keeping me in tune with what my clients are seeing and admiring, I love looking at all the amazing things our creative peers are doing around the world and in all different facets of our industry. I think it's important to look outside your local market (and, more importantly, outside your industry) for inspiration. Trust me, your clients will love you for it.

How to Dress. As crazy as it seems, yes, we are about to discuss wardrobe—again! It's not just at public events like bridal shows that you must put your best foot forward. I'm sure that this seems obvious to most of you, but all too often I see professionals (in the creative industry and other fields as well) just not

> I think it's important to look outside your local market, as well as outside your industry, for inspiration.

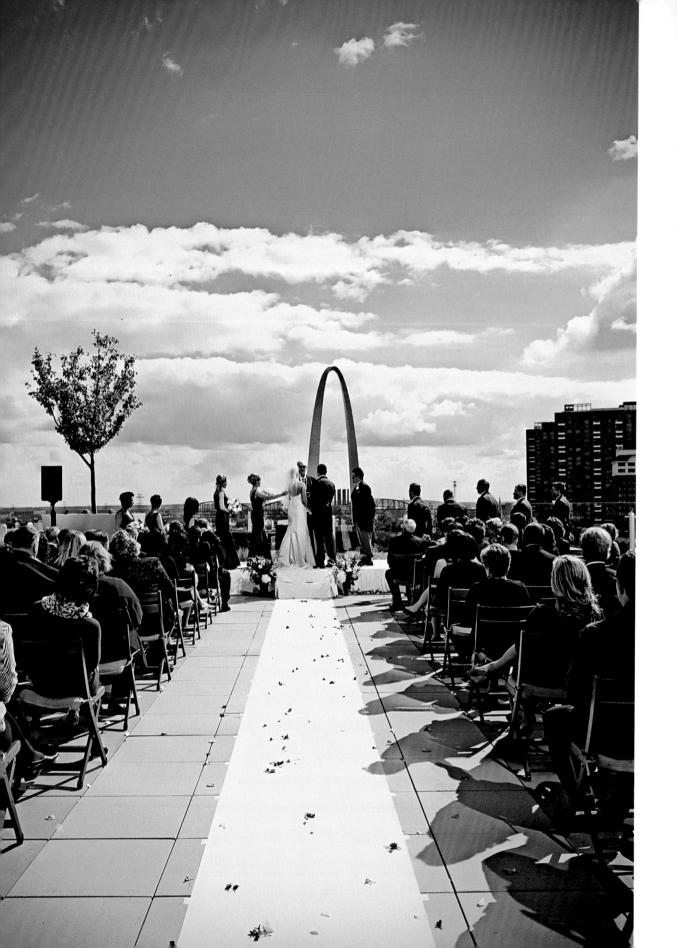

connecting the dots when it comes to how they present themselves. You must dress for success; the old adage is true. That doesn't mean you need to wear a suit to every event or client meeting, however. Again, you should think about your brand and dress yourself in a way that best represents it—as well as in a way that your clientele can relate to.

No matter where we are, we try to make sure we're dressed pretty sharply. I can't tell you how many times we have been tempted to sneak out of the house in our comfy clothes for a late-night movie—only to run into a group of our clients at the theater. This is something we are very conscious of. I am a big believer that we, as the face of our company, are as integral to the brand as our photographs.

I love fashion magazines. I love the clothes, the style, and the pictures. For me, that makes it very easy to stay somewhat up on

We work hard at ensuring all our clients have an amazing experience with us.

the current fashion trends and, as I alluded to earlier, connected to my demographic. Here, though, are some common-sense tips to consider:

- Avoid wearing clothing that hasn't fit in years.
- Avoid clothing that isn't flattering.
- Avoid clothing that has been washed so many times it is now a different color.
- Represent your brand! Yes, in the summer it is hot—but that doesn't mean it's a good idea to show up in a t-shirt and sandals. (And, yes, I have seen it.)
- Shine your shoes, use a lint roller, and iron your clothes so you put your best foot forward.

As an industry, we should be striving to raise the bar. We are not just talking about defining our own brands here, we are working on defining the world of professional photography as whole! This is something I am very passionate about.

As the face of your company and your artwork, you are as much a part of your business's brand identity as any images you produce.

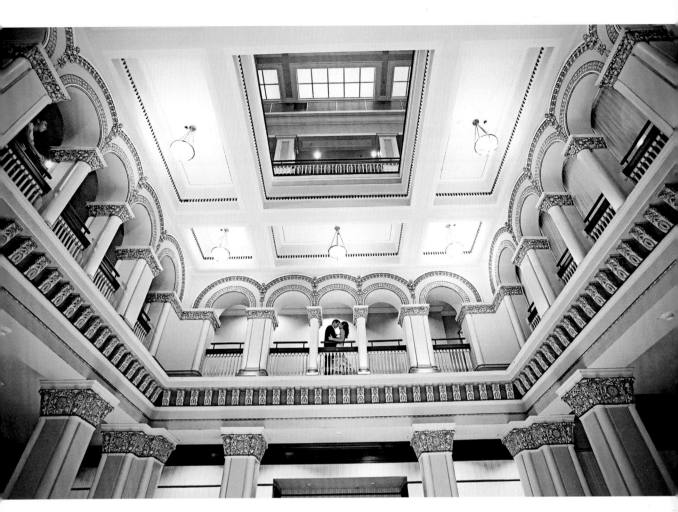

THE BRAND OF YOU

All this talk about branding leads us to one unavoidable and undeniable conclusion: you, as the face of your company and your artwork, are as much a part of your business's brand identity as anything you produce.

The way you carry yourself, how you communicate, your style of dress, the car you drive—all these things define your brand. While this can sometimes be kind of a cool thing, often (and I'm just being 100 percent honest here) it's an exhausting endeavor. I feel as though I always have to be "on" and, to a certain extent, live as a performer.

Don't get me wrong—this business is my baby and I love every minute of it. But it really is important to understand how integral your personal brand is to the overall success of your busi-

It is important to understand how integral your personal brand is to the overall success of your business.

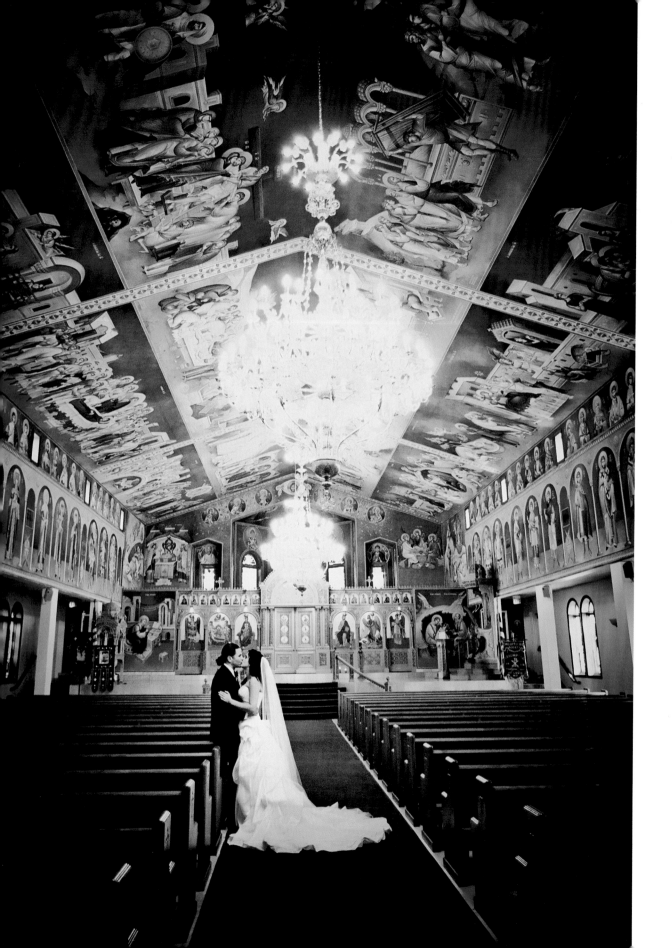

ness. It can be overwhelming at times, but when all is said and done, I like knowing that I am in control of my own destiny.

PRODUCTS TO OFFER

Our product line correlates directly with our brand. We offer very modern and high-end products because that's what our clients expect from us. (Not that any client wants inferior products, but if you are charging $2,000 for a wedding, it makes it very difficult to offer an album that costs your studio $1300. There has to be balance there.)

The point here is to make sure you are offering a product line that connects well with your clientele and your demographic. For example, our brides and grooms see their imagery as artwork for their homes. Therefore, we don't offer products that I see as a little gimmicky. For example, my bride is not looking to purchase a purse with a wedding picture on it. That has nothing to do with the quality of the purse itself, it's only a reflection of our brand and the tastes of our target market.

The same holds true for our seniors, babies, and families. In fact, one year we started carry-

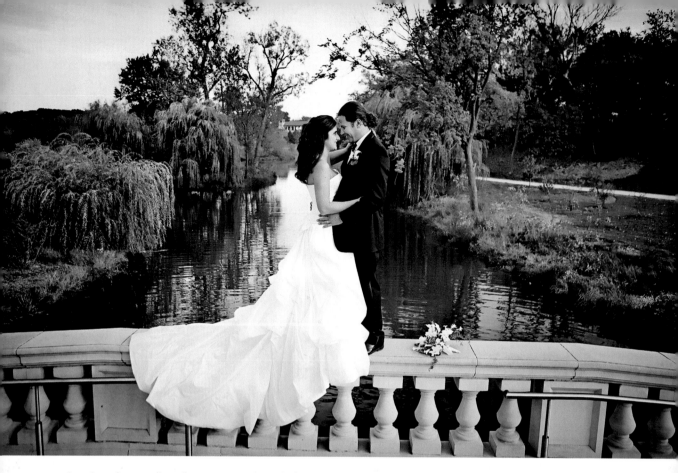

ing jewelry, vanity plates, posters, and dog tags. I thought these things would fly off the shelf, but no one was buying them at all. We weren't even pricing them to make a huge profit; we just saw them as add-on items to increase the total sale. One day I asked several of our clients what they thought about these items. To my shock, they all pretty much responded the same way. In a nutshell, they saw these as cool items, but too gimmicky and not something they were coming to us for. One of them told me, "We can get these items anywhere, but we want something unique for our home and family to enjoy." The message was received loud and clear. Since that day, we have been very conservative about choosing the products we offer.

At our studio, I believe the experience we give to our clients is a huge part of why we have been so successful.

THE XFACTOR

After reading this chapter, I hope we have opened your eyes to a new way of thinking about your business and your brand. Take

this information and do something with it. The worst thing you can do is nothing. It's better to know that you tried and failed than to regret not having tried at all.

This brings me to my final thought for this chapter. When it is all said and done, the one piece of the puzzle that there is just no way to explain is your XFactor. If you don't have that XFactor, then there is nothing separating your studio from the studio down the street. At a certain point, we all take great pictures, have a snazzy web site, display a cool logo, and offer access to the same products—but the things that separate us all from the competition are those intangible elements.

At our studio, I believe the experience we give to our clients is a huge part of why we have been so successful. We work hard at ensuring all our clients have an amazing experience with us. We try to make the day fun and light—we don't want it to feel like work. And our clients love us for it.

This is a skill that has to be continually honed. Remember: it's a journey, not a destination. We work hard each and every year to ensure that we are taking it to the next level and continuing to create some clear separation between us and our competitors. We want our clients to be fanatical and passionate about our studio.

So take some time. Sit down and think about what makes your products and services unique. Then, start putting a plan of action into place.

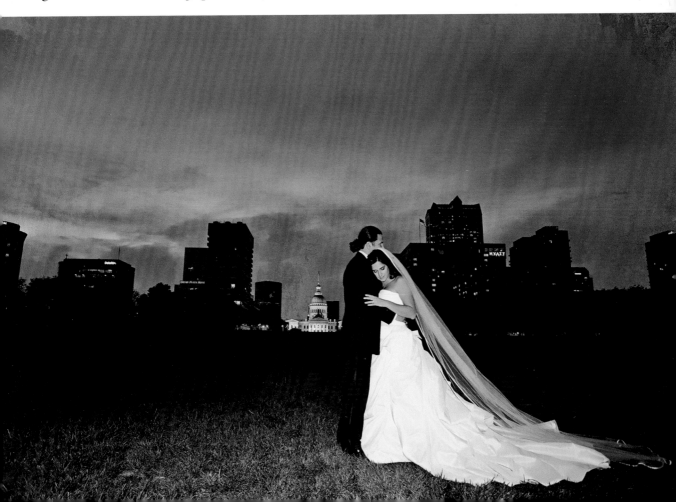

5. A WORKFLOW THAT WORKS

I know, I know. Another guy telling you about workflow. Trust me, I've read way too many books on the subject. Each and every time, I was left thinking that running an entire technology department for a large company would be easier than operating a photography studio. But—wait a second . . . I actually *did* run the technology department of a large company. That's probably why I understand the critical importance of workflow to your

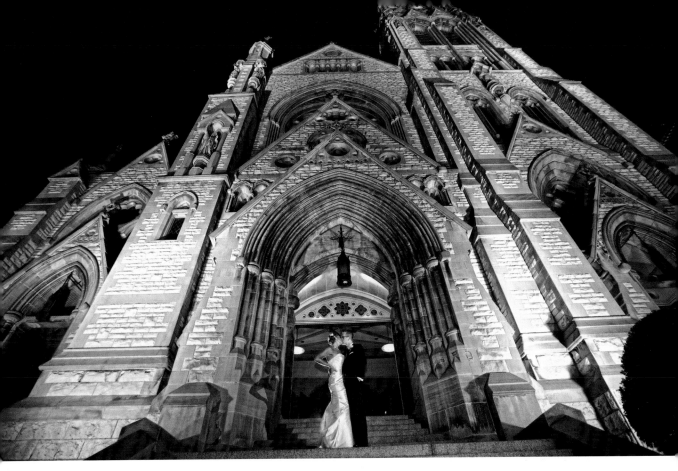

bottom line. The nitty-gritty reality of workflow is this: if you are doing it incorrectly, it's costing you a huge amount of money. And I don't mean only the cost of your time, but the cost of missed opportunity as well. And let's not get even started on the cost of disaster recovery if something were to go wrong with your computer or hard drives.

I'm going to tell you about the actual workflow we use in our studio . . .

Here is my promise to you: I will not give you a bunch of theory that isn't realistic for any sort of volume business. (When I read books or talk to peers about workflow and cataloging and metadata—and on and on—I always end up thinking, "Do these people just have a ridiculous amount of time in their day that I'm missing?") Instead, I'm going to tell you about the actual workflow we use in our studio. Is it perfect? No, but like all things in life and business, it's the pursuit of perfection that keeps us going. What matters the most is that this approach is perfect for us. That's the key; every studio should follow a workflow that suits

their business model and resources. So feel free to benefit from our experience and adapt these ideas to your workflow.

CAPTURE

Let's start at capture. We shoot RAW. Why? Well, there are a multitude of reasons, but the main one is that it gives me the most flexibility in my postproduction workflow. Not only does it let me tweak the white balance, it also gives me some wiggle room on my exposure. JPG technology just doesn't give you that flexibility

Now, I know the flipside to this discussion and I can already hear some readers chastising, "Well, Sal, if you just had your exposure and white balance correct at the time of capture you wouldn't have this problem." While that's certainly an accurate statement, to those people, I say, "Who cares?" I mean, *seriously.* If you have ever shot a wedding, you know it consists of a series of moments happening all day long. I definitely cannot capture those moments when I'm messing around with my camera settings. I would rather spend as much time as possible interacting with my clients on a personal level. Therefore, I practice a guerilla style of shooting that doesn't allow for white balance cards and perfect exposure all the time. Do I strive for perfect exposure? Of course. But in the real world, it doesn't always happen.

The speed at which we work is one of the things our clients love us for—especially on their wedding day, when they want to

The speed at which we work is one of the things our clients love us for.

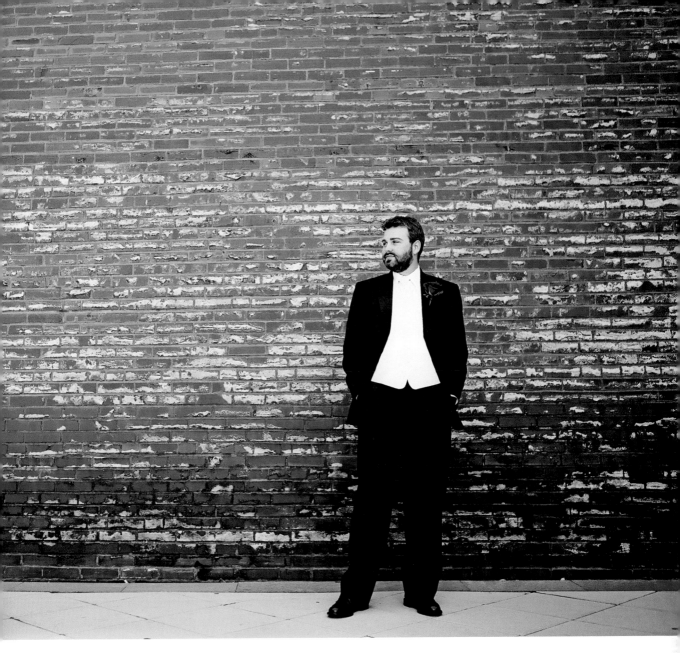

be enjoying their friends and family, not posing for endless portraits. Any time we can give them back is appreciated. Therefore, we use the available technology to our advantage.

There are obviously some negatives to using RAW; the obvious one is the ridiculous file sizes we are now dealing with. That's only going to get worse as cameras continue to produce larger and larger images. This creates problems on both the capture and storage sides of the equation. We now need bigger and bigger memory cards when shooting, as well as larger and larger hard drives to store the image files. In the end, however, we are huge RAW fans and use it to our advantage. I strongly believe the pros outweigh the cons. So, if you are not using RAW

today, I seriously urge you to take a look at this technology as you move forward.

HARD DRIVE TECHNOLOGIES

All this talk about image size is a natural lead-in to storage technologies. Again, this is not a technology book, so I will keep it as simple as possible—but there are some key things I think you should understand.

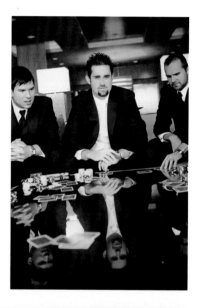

We all know what a hard drive is. They come in all shapes and flavors. We have internal versions, which get mounted inside the computer, and we have the external models that connect to the computer via USB or FireWire. Beyond that, what should you be concerned about? There are three things to consider when adding a new hard drive: the speed of the connection to your computer, the speed of the drive itself, and the size of the drive.

Drive Size. This factor is pretty obvious; the size of the drive determines how much storage space you have to work with. The size of image files is growing with each new camera generation,

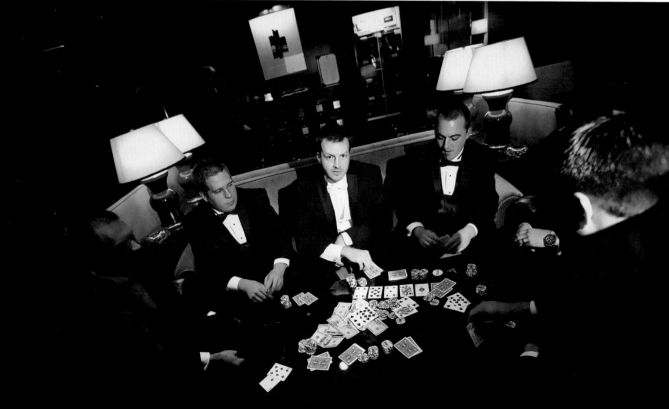

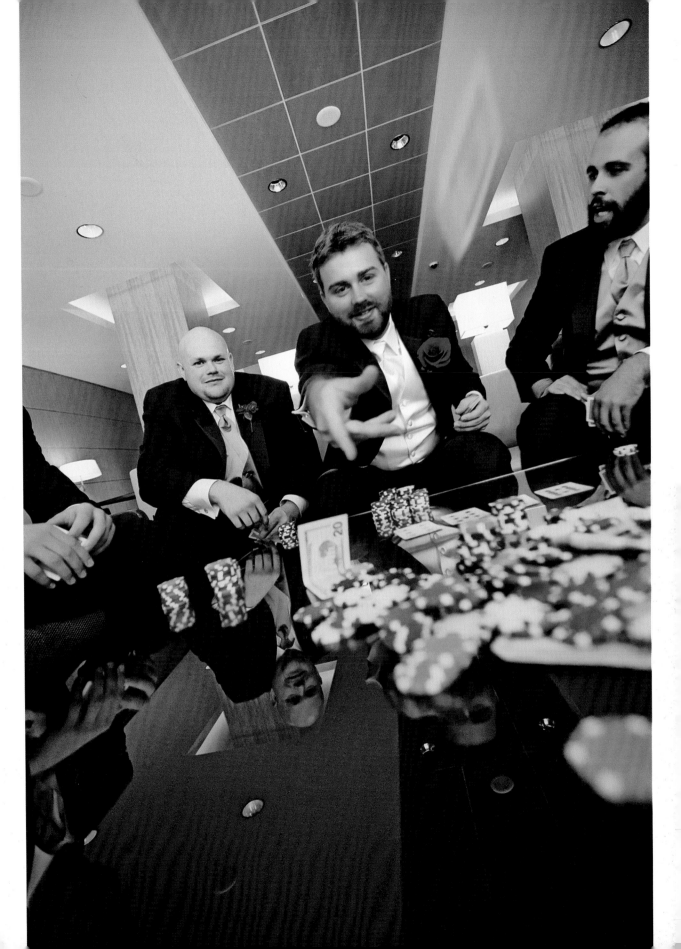

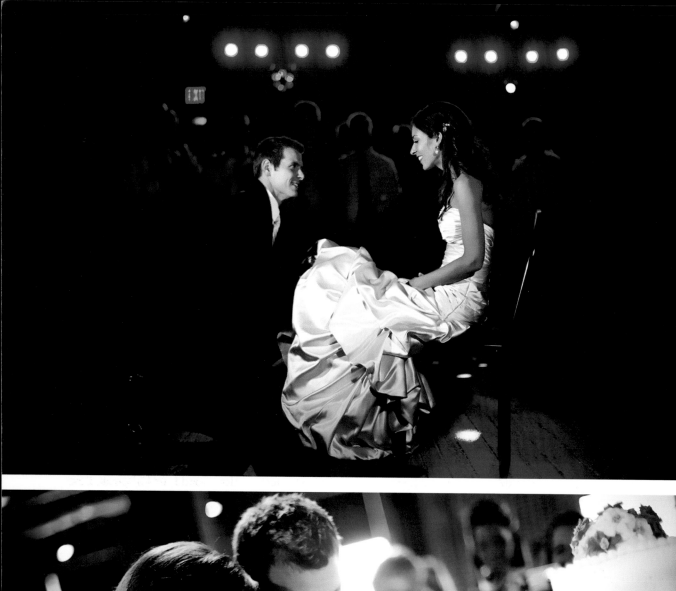
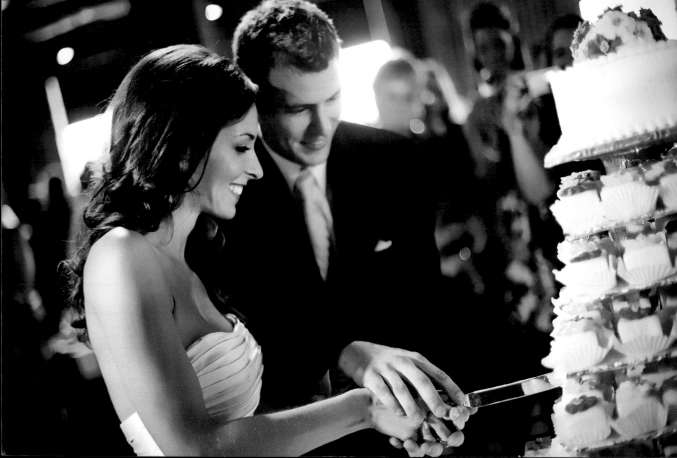

so more is better. If you plan to add video to the mix, you'll be moving toward a world where you need a storage network in your home and studio. (As I sit here writing this book and look over at my workstation, I see twenty-four hard drives stacked up. Wow!) Additionally, keep in mind that hard drives are optimized to work at about 90 percent capacity; when you load a drive to 100 percent, its performance will suffer significantly.

Drive Speed. The faster the drive spins, the faster it can access your data. Drives come in a multitude of speeds. Most consumer-grade drives are in the 5400rpm to 7200rpm range; drives designed for corporate use are faster (and, of course, more expensive). Those little external drives you plug into the side of your computer are typically 5400rpm drives. These drives are great for temporary storage of your images or for moving them from machine to machine. They are horrible, however, for a working drive—meaning a drive you are editing pictures on or actively working with images from. For this type of work, you should be looking for a minimum speed of 7200rpm.

Connection Type. So, now you have all this storage space, and your drives are spinning like there's no tomorrow—but you might still be driving on a highway with a 40mph speed limit. Choosing the right connection type can speed things up. The faster your connection speed, the faster your computer can access the images on your hard drive, so choose the fastest connection type available on your computer (usually USB 2.0, USB 3.0, FireWire, or FireWire 800). We use Macs that come with FireWire 800, a very fast connection speed. This allows me to edit my images and video on the road from my laptop.

DOWNLOADING

So, now you have captured your images. When you get home from your event, it's time to download them. I know that when I get home from an event, it is usually late in the evening and I am exhausted. The last thing I want to do is sit there and download images—but I have to; I never want to risk losing my images for any reason.

The first thing I do when I get home is start downloading the images to my working hard drive. I use a device from Delkin that allows me to simultaneously download four CF cards. Best of all, these units daisy chain together so I can download a total of eight cards at a time.

Once the images are all downloaded to the client folder on my working hard drive, I immediately duplicate them up to a backup drive.

The Delkin CF card reader we use.

At this point, the images are archived in two spots—just in case anything should go wrong with one of the drives. Making this second copy is an extremely important step; don't take a shortcut and skip it.

I should note that we used to employ CD/DVD backups. Eventually, however, the amount of time we were spending swapping out DVDs was just insane. The sheer size of the RAW files we are capturing makes this very difficult. Today, we use dedicated hard drives that are just for backup. We back up every single image taken. We do not cull the images at all. After all, you never know when you will want to go back to an original. Storage space is pretty cheap and your backup drive doesn't have to be the fastest on the market. It's there for one reason and one reason only: an *emergency!*

POSTPRODUCTION

As you approach the editing phase, your images are all downloaded and backed up. Hopefully you have even gotten some sleep and been able to step away from your event for a few days. We try to turn around images for our clients in about two weeks. As our business has grown and we have become busier and busier, however, this has become more and more of a challenge for us. I will talk about how we have dealt with this in a minute.

Image Selection. The process we like to follow for editing is pretty straightforward—and pretty efficient. Let's say we shot 4000 images for a wedding (this is a typical number for our events with two shooters). In Lightroom, we first go through the images and cull them down to about 1500. There's no magic formula here; we could end up with 1600 or 1200 depending on the event. I just go through and flag the ones I want. Don't obsess here or waste time toggling back and forth between multiple images. If you like it, flag it; if you don't, ignore it.

Once we have culled down to around 1500 images, we delete all the unselected images.

When doing your initial edit, don't waste time toggling back and forth between multiple images. If you like it, flag it; if you don't, ignore it.

Gasp! Yes, we *delete* them. Why am I okay with this? Because we still have all the originals sitting on a backup drive if we ever need them. To date, I have only had to go to that backup drive about three times—and it's usually to please a bride looking for some random shot of her uncle Bob wearing a tutu on his head. This process keeps my working drives in good order, leaving me more storage space to use for new jobs coming in.

Image Editing. From here, we start processing the images. Of the 1500 selected files, we like to show the client 700 fully edited images that tell the complete story of their day. It's from these

images that they will be selecting a majority of their album images and ordering prints. The other 800 or so are posted online in a separate directory clearly labeled "unedited," so everyone looking at them knows these have not been touched at all.

I know some of you might be asking yourself why I don't edit every image I show a client—or whether I am concerned about showing people unedited images. The short answer is no, I'm not concerned at all. Nothing goes out of this studio that hasn't been retouched, so even if they order from the unedited section, the client is well aware that their final image will be retouched. There is just no reason for me to spend my time editing 1500 images that the client will more than likely never order. I mean *never!* Time is money, so I prefer to invest my time where there's a better profit to be made.

Instead, we show the client what we believe to be the best images—and we fully process these. To us, "fully processed" does not just mean making the minimal white balance and exposure

We show the client what we believe to be the best images—and we fully process these.

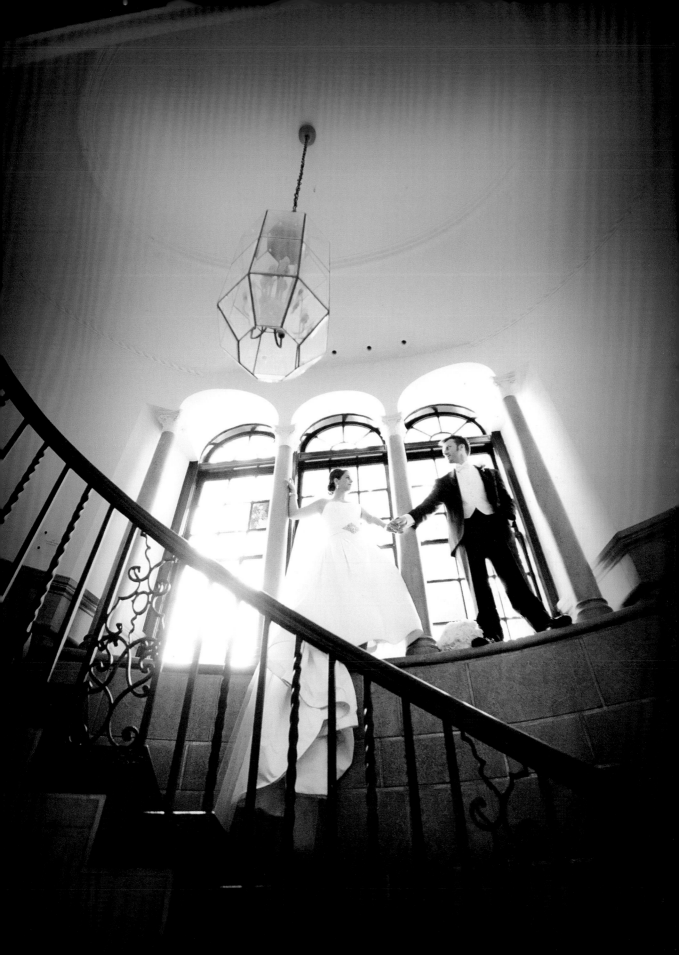

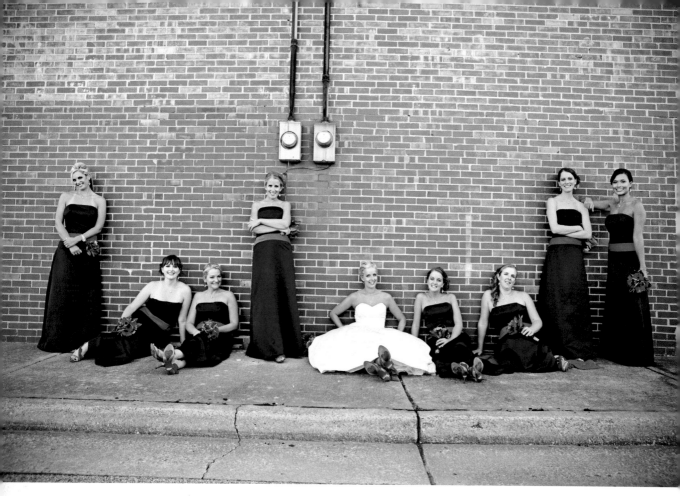

corrections. We show them their images the way we believe they should look, doing black & white conversions, sepia toning, and a slew of other editing options (we all have our own recipes). My thought process here is simple: I cannot expect the client to have enough vision to figure out what a given image would look like in black & white or with a special editing technique applied. They hired us for our vision, so we show them our vision of their day.

Ultimately, this approach leads to higher sales for the wedding because our clients see images that they immediately want to have for their home. When viewing the final images, they can easily see our work as art, not just pictures.

Lightroom *vs.* **Photoshop.** We use Lightroom for 90 percent of our image editing. It is an amazing tool and, in my opinion, one of the best on the market. If you are not using it, I suggest you download a trial version and get wowed!

They hired us for our vision, so we show them our vision of their day.

Lightroom allows us to add metadata, do non-destructive editing, make slide shows, catalog files, create a web gallery, and so much more. As the tool has become more popular, there has also been an explosion of plug-ins for it—and that's where the true power of Lightroom is found. We can, for example, upload directly to our blog and add our watermark instantly. If that's not efficiency I don't know what is.

Where does Photoshop play into all this? There are some images, we call them "Photographer's Select," that need more heavy lifting. This is when you call in your big gun—and that gun is Photoshop. We like to isolate about twenty-five of these images for each client. To these we apply filters, beauty edits, textures, etc.—designing a flawless piece that can truly be showcased as art.

Keep in mind, though, that Photoshop edits are destructive. Once you start working an image, you will not easily be able to go back to that image in its original state—or, more importantly, instantly apply the same edits to another image. These operations are very easy within Lightroom.

Outsourcing. As noted previously, as our studio has grown, our goal of delivering client images within a two-week window has become more and more of a challenge. We are currently shooting over fifty weddings each year, so the only way we have been able to keep pace with our busy schedule is through outsourcing.

You read that right: we outsource many of our postproduction tasks. This has been one of

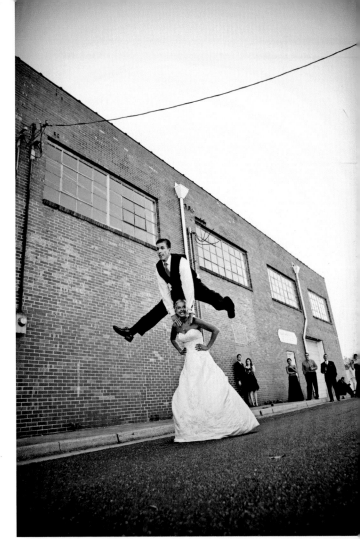

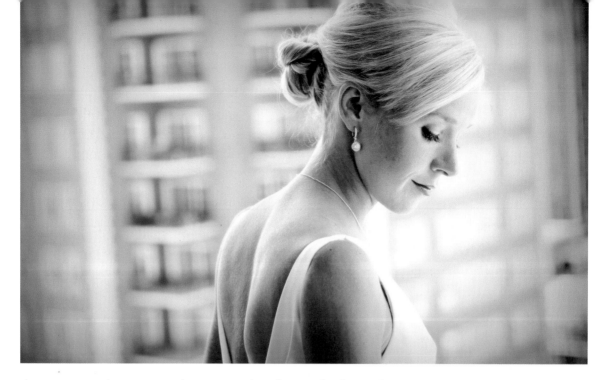

the most amazing steps we have ever taken for our business. As the owner and main photographer, my time is better spent creating images rather than sitting at a monitor adjusting contrast and white balance settings.

We use a company called Revolution Imaging and Design (www.revolutionimagingdesign.com), and these guys are amazing to work with. They do everything from culling your images, to color correction and exposure, to full-on creative edits, to album design. Not only do they do it, they do it well. In my opinion, they are the best in the business. I believe in them so much, we have bet our business on it. Our growth has been directly tied to their ability to meet our demanding clients' needs and aggressive turnaround times.

The best part about the whole thing is that their editors worked with me directly to ensure they would be matching our editing style. As a result, our clients see exactly the same quality of images from our studio that they did when we were editing them in-house. If you are not able to meet reasonable deadlines for your clients, outsourcing is definitely something I would consider exploring.

This has been one of the most amazing steps we have ever taken for our business.

ORDER FULFILLMENT

Now, let's fast-forward to the sales presentation (sales will also be covered in the next chapter). This is an area that can be somewhat confusing to figure out. For us, after editing everything in Lightroom, we export the images as full-resolution JPG files. We then present these files to the client using a different machine in our studio. (We use those wonderful little hard drives we spoke about earlier to move the images around.)

As the clients select the images for their wedding album, prints, etc., we use Lightroom to flag the selected images. Right after the meeting concludes, my wife, Taylor, exports those im-ages to a print order folder. From there, I get the order.

From the 700 images we showed the client, the twenty or so they selected as their favorites are sitting right there, at full resolution, waiting for me to order from. This saves me so much time! In the past, I had to go on a hunting expedition (check the order form, then choose the image from the directory of 700, look at the order form again, then find that file, and back again, etc.). It usually took me ten or fifteen minutes to get all the images together—and it was a complete waste of time.

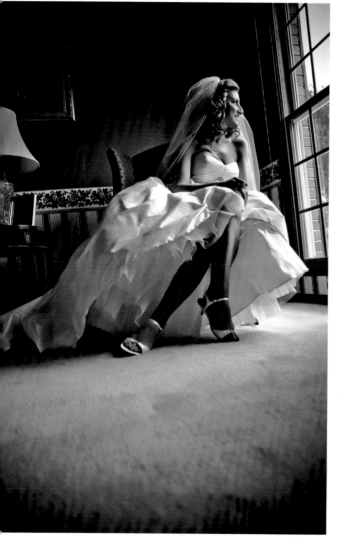

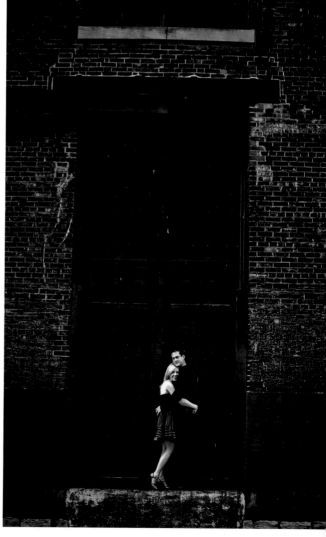

SELLING YOUR IMAGE FILES

Whether or not to sell your full-resolution image files (and whether these should be edited or unedited) has been the bane of many a professional photographer's existence. My thought on the subject is that if you are going to include them, you have to make sure you are getting enough money for them to make up for the print sales you will be losing. After all, once people have those files, they usually think they can go to the corner store and make great prints.

For me, part of this is an education issue. My clients know they cannot get the same quality print from the corner store as they can from me. After all, our clients see our work as art (something we've established through our branding), and you don't get art at the corner store.

In our higher-end packages, we do give the clients their files. We do not, for obvious reasons, offer this in our lower-end packages—and we do not, under any circumstances, supply clients with our fully edited images. The idea of investing all that time, money, and energy on editing images to perfection and then basically giving them away for free seems nuts to me.

Don't get me wrong. I have lost many wedding bookings from clients who told me, "Well, Studio X is giving me fully edited engagement images and wedding images—and a new car and a lake house." I have to sit back and say, "Wow. That's awesome. I'd book Studio X. It sounds like they are giving you a great deal." Usually, Studio X offers middle to sub-par imagery that does not give the client a high-end experience.

Because I am pretty confident that we are offering both a superior product and a better service, I always end those types of discussions with some food for thought. For example, I ask the client to define "fully edited." Usually, when photographers are offering this, they are giving you very few images and they are only color correcting them. I then show them some of our over-the-top edits and tell them, "I doubt they are doing this. And the reason I doubt it is because it takes too much time to make this image look the way it does." The next question I ask is, "What sounds better to you: getting 200 to 300 half-processed images on a disc or seeing 1500 images with 700 of them processed to perfection for you?"

My goal here is to get them thinking about what is important to them. As I noted earlier, some people *will* opt for those 200 half-processed images on a disc—and I'm okay with that. Ultimately, that's not my optimal type of client; I do not want to book every single wedding that comes my way.

A WORKFLOW RECAP

Ending this chapter, let's recap our workflow:

- **Capture.** Use RAW for the greatest amount of flexibility. Get the fastest CF cards possible to ensure they can keep up with the frame rate of your camera.
- **Working Drive.** Download all your images to your working drive. This should be as fast as possible.

We do not, under any circumstances, supply clients with our fully edited digital images.

- **Backup.** Use external hard drives to back up all the images before you cull any out.
- **Purging.** Cull your images on your working drive to your best images from an event. Delete the rest. (Ensure you have backed everything up first.)
- **Processing.** Edit within a tool like Lightroom and export high-resolution files for the client's presentation. (We are big proponents of in-studio selling; more on that in the next chapter.) For your more special edits, export to Photoshop and work on a copy of the image.
- **Order Fulfillment.** Export the images selected by the client to a special order folder where you can easily access their files for quick ordering.

If nothing else, I hope this has encouraged you to think about what you can do to streamline your workflow. Rooting out inefficiencies will pay huge dividends in the form of time. With that time, you could shoot more—or just sit back and relax.

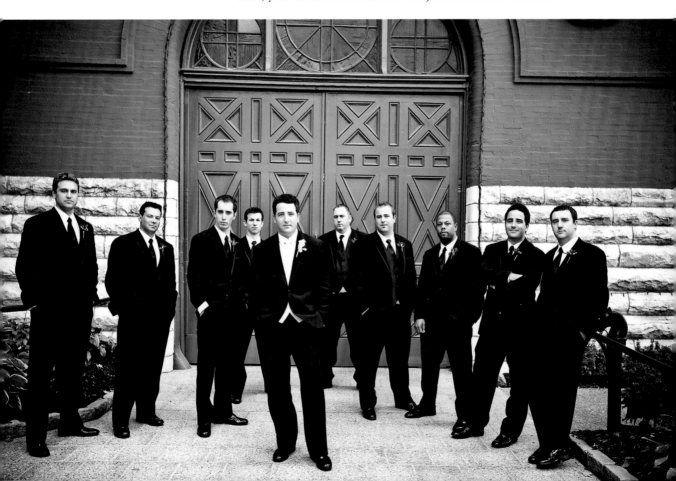

6. SELLING: WHERE IT ALL COMES TOGETHER

You're an artist, not a salesperson, right? Wrong! Nothing could be farther from the truth. This is not a click-it-and-they-will-come business. We have to be able to sell the value of our products and services. If not, no one will do it for us.

No matter how great of an artist you are, you have to think about your sales process. I don't know about you, but I didn't get

into this business to be a starving artist. There is nothing romantic about that. And like every other American chasing their dream, I hope to be able to retire someday. In order to accomplish a goal like that, we need to get you up to speed on some selling strategies and tactics.

In this chapter, we are going to explore our process, how it has evolved, and examine our successes and failures. When all is said and done, we have a very healthy contract average and a very healthy post-event average. So, we must be doing something right.

THE SOFT SELL

Selling does not start in the sales room; selling starts long before that. We are big believers in the soft sell. I hate, with a passion, the use of high-pressure tactics. I smell them a mile away and almost never respond to them—mostly on principle. It's just something that has always irritated me and I promised myself we would never operate that way. Of course, that doesn't free us from the need to operate with a sense of urgency and guide our clients through an actual process.

ESTABLISHING A SALES PROCESS

The first thing you have to do is commit to having a sales process. Our sales process is something we have refined over the years—and trust me, the road wasn't always a smooth one.

If, like many other photographers, you are selling online, you are losing money on each and every sale. When we first started out, we

used an online sales gallery and our average engagement sale was about $125. No lie! It was *dismal*. People were buying 5x7s and 4x6s, picking the wrong images, etc. We were spending all this time prepping for their shoot, doing the shoot itself, and finessing the postproduction work—and when all was said and done, we were making less than $10 an hour. I'm sure I don't have to tell you this, but at $10 an hour there is no way you can market, advertise, buy

new gear, and do all the other things that go into running a top-notch studio. We knew something had to change—and quick!

At that point, we were working out of our home studio. For the record, I don't see anything wrong with that. When you are first starting out, there is no need to incur the expense of a commercial space. That's especially true if you are a wedding photographer, since we rarely need to shoot indoors. For wedding photography, the only reason you need a business space is for sales and consultations. We knew we had to find a way to bring people in, show them their images on a big screen, present the various products we offered, and demonstrate how we would display these images in their home.

One day, we just decided to try it. We were not prepared at all. We didn't have a whole lot of samples to show, but I knew I wanted to experiment with it and see if this approach was worth pursuing. Our very first in-studio engagement sale was $1400! We went from $125 to $1400 just by bringing the clients in and

When you are first starting out, there is no need to incur the expense of a commercial space.

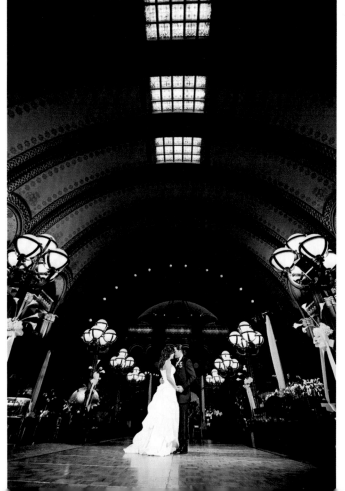

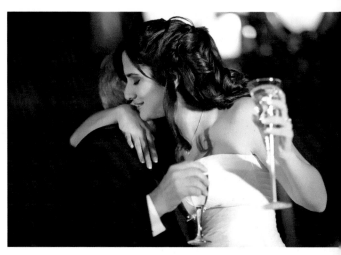

walking them through the process. There was no gimmicky sales process and no shady first-ten-callers-only offer.

That day was a eureka moment for us. The light went on and we completely changed our sales process. Today, we do not offer online sales. To be honest with you, I see it as a complete disservice to the client and my work. How in the world can I expect a client to share (or invest in) my vision when they're looking at some small 72dpi image on their screen at home, distracted by fifty other things going on? Now, we bring them into the studio, show them big, full-resolution files, and let them completely focus on one thing and one thing only: their images!

We make an event out of it. We serve champagne and invite them to bring their families along. The whole process takes about two hours, as we talk about their honeymoon, enjoy the images, show them our favorites, etc. Almost every client who experiences that process ultimately thanks us for helping them through it—because they know they would not have been able to complete it on their own.

Trust me. You need to find a way to make it happen. If we could do it out of our home, so can you. There are numerous success stories in our industry of people doing it that way. So stop telling yourself it can't be done and do it!

PACKAGES

Driving the Sales Process. I am a big believer in implementing a system of packages; we offer wedding contract packages, engagement packages, and post-wedding packages. By creating effective packages, we can control consumer behavior. Instead of a hard sell, we let our packages, and their bundled value, drive the sales process.

With this system in place, we don't have to put any pressure on the client. We don't even have minimum orders. For example, for their final order, the only limit we place on the couple is they have to make a decision on the night of the viewing session. The pricing is sent to them the week before, so there are no surprises. When we are showing them their images, everyone knows why they are there: to make some decisions. The pressure comes in the form of making an emotional decision about what they want and how much they are willing to spend. Having them in the studio with their family ensures that all the decision-makers are present and ready to listen to our guidance.

Having the couple in the studio with their family ensures that the decision-makers are all present.

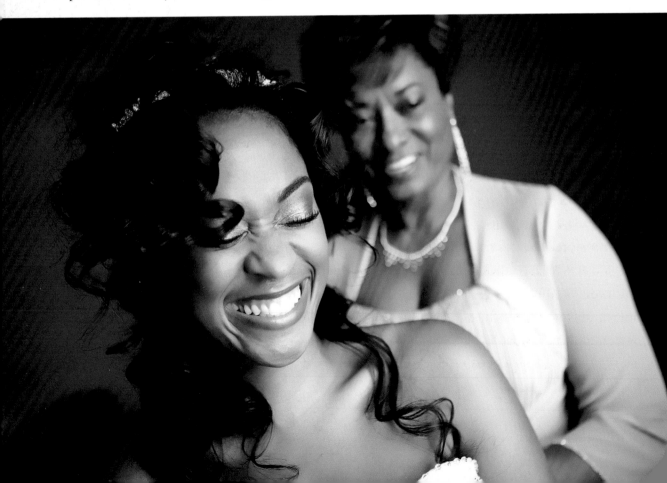

Packages and time-sensitive specials create a sense of urgency. Without them, there is absolutely no reason for them to decide on their purchase while they are still newly excited about the images and most willing to spend money. As a result, your sales will suffer. I don't know about you, but I have never had a client come back two months after a wedding and spend $1500 or more on prints. This is not a practice I would recommend embracing; it's too unpredictable. Without an incentive, you will undoubtedly end up with no sale or find yourself resorting to high-pressure tactics—neither of which is an attractive alternative to me.

Custom Packages for Each Client. We create custom post-wedding packages for each client. These packages are tied to vendor specials and have an expiration date. Why do we go through the effort of creating custom packages for each preview? Well, each client is different. They have different needs and different tastes. For example, some people love canvas; others couldn't care less and are just looking for square prints or one monster print.

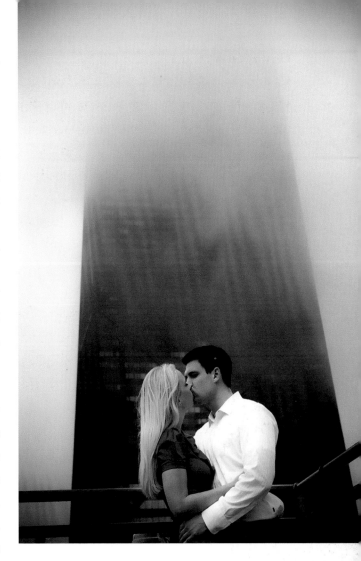

How do we know what our clients are looking for? Remember when I told you that selling starts long before the couple comes in to see their pictures? I am always talking to my clients about what they like and don't like. For example, if they buy a big canvas from their engagement session, there is a very good chance they will be looking for a matching one from their wedding. If they come in to see their engagement pictures and tell us they just don't like

canvas, well, guess what? Their wedding sales packages will not have a single canvas option in them. Your packages have to be compelling to the client, not to you. If you spend some time figuring out your clients, the sales will come.

Post-Wedding Package Options. We usually put three packages in front of the client: a good one, a better one, and the best one. I never do more than three, because it gets too confusing. Also, the packages must have very clear lines of separation, ensuring there is something for everyone. (This is the same approach

we use when presenting our wedding contract and engagement packages.)

Each post-wedding package gives the client a discount over purchasing à la carte—but there is one package on the paper that gives them the best deal, usually 30 to 40 percent off our à la carte prices. How can I give such steep discounts? By pricing my products correctly, I've given myself plenty of wiggle room. In essence, my packages are a way of rewarding them for spending at a certain price point.

In essence, my packages are a way of rewarding them for spending at a certain price point.

Here is an example of what some packages might look like:

Package 1 ($899)
- All gift-size prints. Nothing large at all.
- Discounts around 15 percent.

Package 2 ($1599)
- Some mid-sized prints (maybe a 15x30 and a 16x24) and some gift sizes.
- Discounts around 20 to 25 percent.

Package 3 ($2499)
- This is our loaded package and the best deal on the table. This might have an album upgrade, extra pages in the album and two larger canvases, along with some gift sizes.
- Discounts around 30 to 40 percent (depending on what specials our vendors are running and my cost on certain items).

The point here is that I want them to invest in that $2499 package, but I am not going to sit there and strong-arm them into it. As they look through the packages and start adding up each à la carte item, they quickly realize on their own that they should be purchasing a package. I can't tell you how many times we have had people walk in the door and tell us they are not going with one of the packages—only to walk out having purchased

our top package. And this was accomplished without us pushing them at all, which is soft-selling at its best.

Presenting the Packages. When presenting our packages to the client, we have everything printed on very high-quality paper. We then place the paper in a nice, restaurant-style leather menu holder for them to read. Even though they have received this information prior to coming in to view their images, we still walk them through the packages and show them each and every product in the package. In addition, we present our recommendations for the larger size prints in each of the packages. We present our most expensive package first. Then, we walk them through what they *won't* be getting in the other packages. Basically, we are pulling products out rather than adding items. It's just a psychological thing for me.

During the engagement sales session, we show clients a slide show of about 200 images from their shoot.

OUR SALES PROCESS

Now that you understand what we are doing and why we are doing it, let's step back and walk you through how we are doing it.

The Initial Consultation. After the client has seen our work online, we like to set up a meeting. Most of the time, we do this face to face. If the client is out of town, we set something up via iChat. Our wedding contract packages are set up the exact same way as our engagement and post-wedding packages are. We give them several options, all driven by products and services. The important thing is to ensure there's a key difference between each package tier. If you offer ten hours of coverage, a wedding album, and all the original images on CD in your base package, no one is going to book your top-of-the-line package. We use albums, time, and image files as our pull-through to the pricier packages.

The Engagement Sales Session. After we shoot their engagement pictures, we schedule

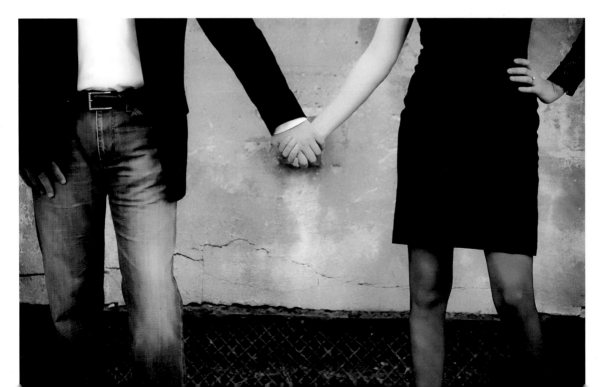

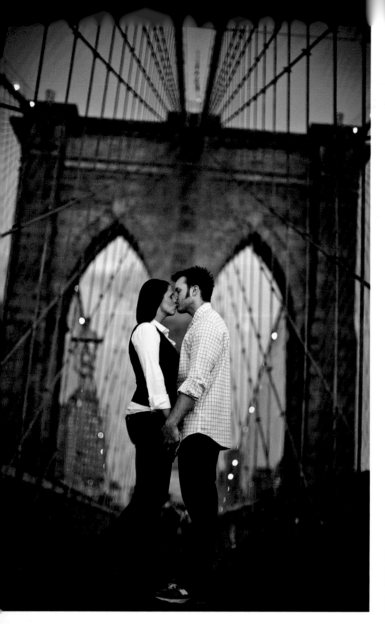

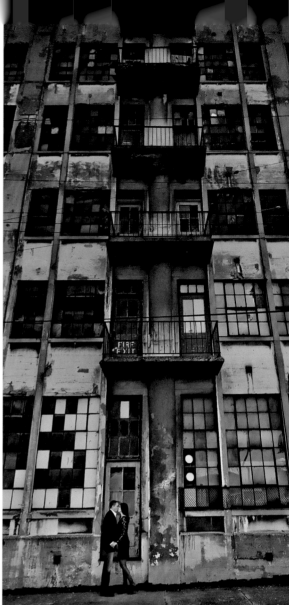

a time for them to view and order their pictures. We send them pricing in advance, so there are no surprises. Once they are in our studio, we show them a slide show of about 200 images. These are fully edited and processed images. After the slide show, we walk them through the packages we sent them and show them all our products and recommendations. Once we've done that, we ask them to tell us how they would like to proceed and what package they are looking at. That's it. Do we hear objections? Of course we do. I will cover that at the end of this chapter.

We send each couple pricing in advance of the engagement portrait ordering session, so there are no surprises.

The Wedding Sales Session. About two weeks after shooting the wedding (depending on the length of their honeymoon and personal schedules), we conduct their preview session. This is extremely important. You have to get them in to see their pictures *as soon as possible*—while everyone is still excited and in wedding mode. If you wait much longer, everyone will have moved on; there will be things around their home and in their personal lives that override any excitement about the wedding pictures. That is a huge miss for you. We have even had situations where four weeks after the wedding, the couple learns they are pregnant. From that point on, they are in baby mode and all their discretionary income will move toward preparing for the new arrival. Again, that's a huge miss for you.

At the wedding preview session, we start the evening out with a champagne toast and spend about twenty minutes just talking. Don't start looking at your watch to make sure you are talking for twenty minutes. This is just a social exercise; at this point, you should have naturally bonded with your clients, so the conversation flows naturally. For us, we really feel like we are having friends over to the house. Keep in mind, by the time this session

At the wedding preview session, we start the evening out with a champagne toast . . .

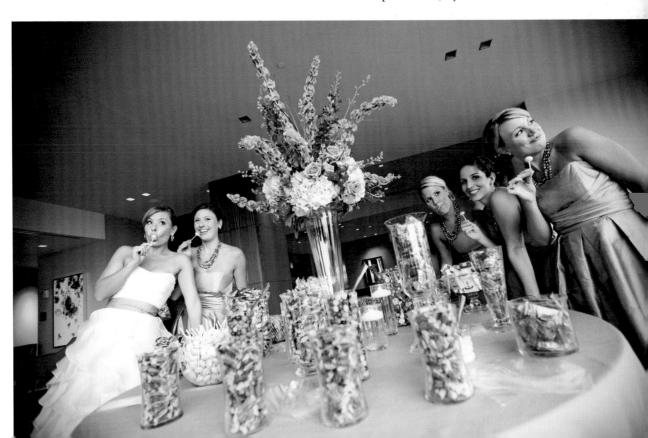

rolls around, we have been working with some of our clients for over a year.

Once we are done catching up, we go into the presentation room, and show them a slide show of about 700 images. It's absolutely amazing to sit there and relive the day with them. Almost every single time we hear, "Oh my God! I don't even remember that happening!" I love when I hear that; it lets me know we have done a large part of our job, documenting the day for our clients.

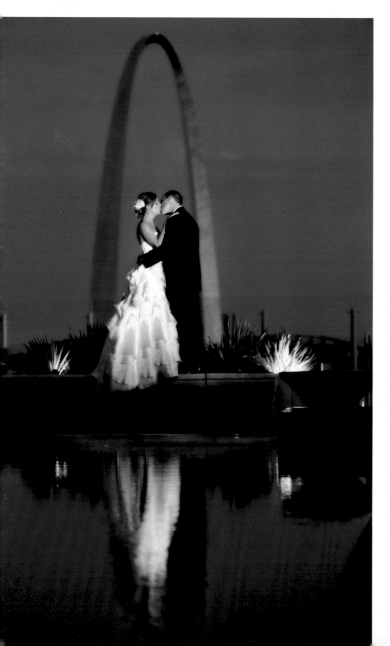

Once the slide show is done, we walk them through the packages we sent them earlier in the week. Having purchased engagement portraits from us already, they are very familiar with the process, so there are no surprises. The packages are clearly different from the engagement session. We may have parent albums bundled in or offer larger canvases and extra pages in their album. There are always lots of different options for them and their families to choose from. We conclude the same way we did for the engagement session, by asking them what package they are looking at.

Sometimes, we don't even get through presenting our biggest package before the client cuts us off by saying, "That's what we want—we're not interested in the smaller packages." Of course, I love days like that. Other times, there is some back-and-forth debating between the couple as they try to figure out what they want to do. A lot of times, they walk in thinking they will just stick with what they have already purchased with their wedding contract. Then they see the images and everything changes. I tell all my clients that my job is to create amazing images for them; their job is to resist. There is a lot of truth in that statement—and it keeps things very light.

That's our sales process in a nutshell. While relatively simple, we have found that it is capable of yielding tremendous sales results. I encourage you to think

about our process and try out any of the ideas that seem like they might work for you.

HANDLING OBJECTIONS

Now, of course, I have been focusing on the positive side of all this. Like every business, we also encounter objections from our clients. It is important to acknowledge that objections *will* happen—and that it's okay. What's important is how you handle those objections. If the client has an objection during the sales cycle and you cannot adequately address it, the sale will either be lost or put on hold until their concern is resolved.

Understanding a client's objections often requires reading between the lines. All too often, photographers don't even realize they are getting resistance from the client until it is too late. You have to listen to your client and really think about what they are saying to you. Not everyone is going to have an assertive personality and come right out and say what they are thinking.

Once you have identified their issue, you must offer a solid response that correctly addresses their concerns. Here are just a few objections we hear from time to time:

- Can you post the images online before we come in?
- We want to wait until after the wedding to buy some engagement pictures.
- Our parents aren't here and they are the ones paying.
- My fiance couldn't make it today, so I can't buy pictures until I talk to him.
- We don't want anything big. That would just be weird to see a huge picture of us on the wall.

- We are just looking for a few big prints for the house—like an 8x10 or something.

These are nothing earth-shattering, but they can quickly derail your sales meeting if you're not prepared to respond to them. After doing this a few times, you will have heard 80 to 90 percent of the objections, so you should be ready for them. Of course, every once in a while, clients will surprise us with something new—then Taylor and I just laugh, thinking, "Well, okay. We didn't see *that* one coming!" But all-in-all, you should be able to prepare canned answers for most objections and help the client get past their issue. If you haven't done this already, get to work on it.

7. ESTABLISHING RELATIONSHIPS

My hope is that you have read this book so far with an open mind and come away with a new way of thinking—a mentality that enables you to find success and deal with the challenges we all face as artists and businesspeople. A lot of what we have covered thus far has been easy to measure and implement. This next topic, however, is not as easily quantified and its implementation can take years to master. For some, this is the missing piece of the puzzle; others wander around clueless as to how others manage to do it. Our topic is relationships! And, once again, I am here to tell you that you can be the best photographer in the world and still *not* succeed—because, when all is said and done, there is much more to what we do than just crafting images. We are in the business of building relationships. It is these relationships that will pave the way to our referral future.

When all is said and done, there is much more to what we do than just crafting images.

THE CYCLE OF LIFE

There is a clear cycle of life in our culture. People get married and have children. Eventually those children grow to be high school seniors—and when they get engaged a few years down the road, the cycle begins all over again. We can enter this cycle at any point in the client's life; some people will find us when they are already married, others will find us when they are planning their wedding, still others will come our way when their children

become high school seniors. Once they come to us, though, we should be targeting them each and every step of the way.

The "Pre-Bride" Approach to Marketing. Our studio spends a significant amount of energy ensuring that our clients are educated about all the services we offer. Our high school seniors are some of our biggest wedding fans. They love looking at the images and often talk about their own big day. It sounds crazy, but trust me—even kids who haven't gone off to college yet are thinking about it. They plan to get married some day, just like they are planning for college now. Sure, it's in the back of their minds, but that doesn't mean we can't start planting seeds—and not only for them, for their parents as well.

Have you ever thought about creating a lifetime program for your seniors? Maybe offer them a discount for when they start planning their wedding? Just plant a seed. Who knows—say only 10 percent of them take you up on that offer. If you do 100 seniors per year, that means ten of them from each year will come back to you when they are getting married. That becomes a huge referral engine. Honestly, regardless of how many come back, it's free and easy marketing.

Take it a step further. Think of all the families that come to you for senior pictures. Do you think they might know someone getting married? Every year, we book two to three weddings that were referred to us by one of our senior portrait clients. It's marketing genius! If

Think of all the families that come to you for senior pictures. Do you think they might know someone getting married?

you are not bringing the cycle of life together for all your clients, you are missing out on some low-hanging fruit.

Another thing we offer all our high school seniors is a free family session. (I know what you're thinking, "Sheesh! This is a *wedding* book. Are we are still talking about high school seniors!" Yes, yes we are. We attack *all* our lines of business with equal zeal because we know that referrals can come from anywhere. We want to make it as easy as possible for our clients—our biggest fans—to refer us out and continue to work with us throughout their lives.)

We shoot over a hundred senior portrait sessions every year, and each of those seniors comes from a family. So why spend our time and energy trying to find new families and new clients when we have existing clients who need and want a family session? They are already excited about our work and have seen the results with one of their own, so getting them to sign up for a family session is not all that difficult. This is another opportunity to win the family unit over. After working with us multiple times and decorating their homes with our amazing images, who do you think they will call when their son or daughter gets married? You guessed it!

We shoot over a hundred senior portrait sessions every year, and each of those seniors comes from a family.

That's why this is so important (and why I have spent so much time writing about it). This is a huge opportunity for you and your business, yet it's one I often see ignored.

The "Post-Bride" Approach to Marketing. Now that we have an understanding of working the cycle of life as it pertains to pre-brides, let's talk about creating a program for our brides once they have had the opportunity to work with us. This is a "post-bride" mentality, if you will.

At our studio, we offer a "client for life" program to our high-end wedding clients, giving them a free photo shoot once a year for life. The value of this program is clear; you have clients who love you, and this makes it easy for them to continue to work with you. We do sell this program, but the real value lies in bundling it within our packages.

Now, before you start freaking out about us giving away free sessions, think about what we are doing here. We do not make our money on session fees. Sure, it's nice to have that income, but we make our main revenue on the print sales that follow. Through the use of this program, we are creating a new revenue stream for our business. As our couples move through life, they know they have a photographer they love and trust for all the important moments in their lives.

So think about creating some sort of reward program for your best clients. Don't miss out on key marketing opportunities and the ability to pick some low-hanging fruit for your business.

Tailor the program to the needs of your client base. For us, free session fees have worked. In your region, they may get excited about free prints. And don't be afraid to poll them—to ask your clients for feedback. If they are good clients who love your brand, they are usually more than willing to give you their honest opinion.

WORKING WITH CHARITIES

If you really want to take it to the next level and get some personal satisfaction at the same time, start working with your local charities. It's a perfect opportunity for you to help out the local community and generate some new revenue at the same time.

I must admit, when we first started working with the local charities, we had a very difficult time making it work for us. All too often, people would buy our give-away or raffle item and not redeem it. We had no contact information and no way to forecast when, where, or how this would impact our bottom line. If you have learned anything from reading this book so far, you know that, for us, this was an unacceptable situation. Therefore, we started making some changes that have made this a worthwhile endeavor for us—and for the charity we are supporting.

First and foremost, donate something of value. This doesn't have to be (and really shouldn't be) a high-cost item. Remember, our time has value. Depending on how you have positioned your brand, this value can be quite significant. We like to give away a free session fee. This alone carries a $200 value. Sometimes, we add a free 11x16-inch print, bringing the value of the package to $399. Either of these options can raise a nice amount of money for the group and typically bring a very excited new client to our studio.

When we first started working with the local charities, we had a very difficult time making it work for us . . .

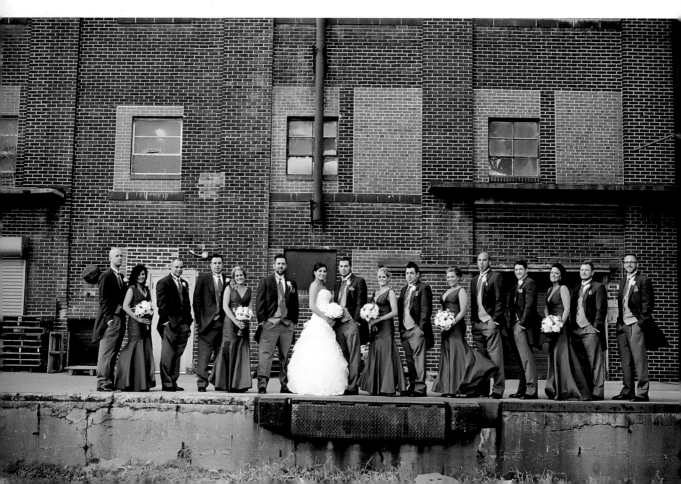

We also inform the charity that, in order for this to be redeemable, we must have the name and contact information of the winner. This has been a huge improvement for us; now we know who won and can contact them within a week of winning to get something scheduled. That way, we are driving the relationship rather than reacting to it, which allows us to forecast better and closely monitor the value of participating in events like this.

Also, we tie an expiration date to the give-away. Yes, we are participating in order to help the local charity, but we are still a business and the last thing I want to do is have all these coupons sitting out there with no one cashing them in. The ultimate goal for us is to conduct the shoot as soon as possible and bring in additional revenue from the print sale. Sure, it's possible for someone to come in, take their free print, and run—but I am banking on the fact that they will love their images and spend additional money with our studio. So we want them to come in soon. After all, they spent their money buying the raffle item, so they are obviously excited about having portraits made.

Finally, we give the charity a nice display to showcase our work and get people excited. We are in the image business. If we just supplied a 4x6 coupon or some lame raffle sheet, we'd be doing our business a huge disservice. To make a real statement, we frame a print and display it on an easel along with a nice coupon for the winner to take home. Try it. It will make a huge difference.

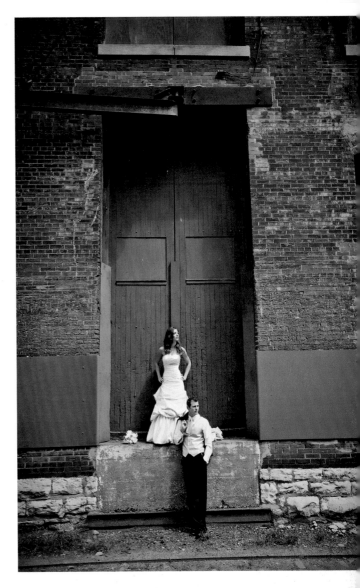

PRO BONO WORK

Another great way to forge relationships is by doing some pro bono work. Gasp! I know; there is a school of thought out there that shuns doing any type of professional work for free. The argument is that if you do it for free, it is never appreciated—and you are, in essence, devaluing your brand. Ordinarily, I would agree with that. However, we have had years of experience

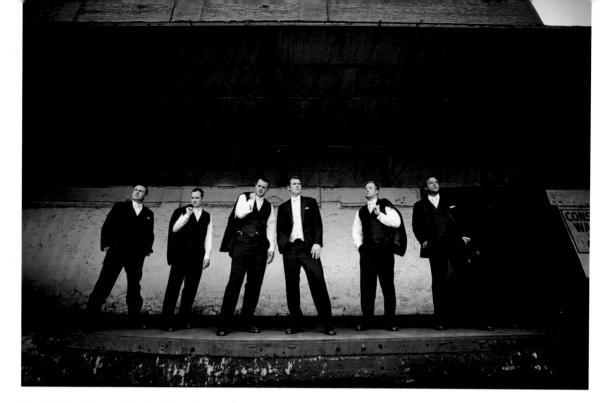

working with vendors and various other groups that have yielded amazing results.

Now, don't misread what I am getting at here: I am not suggesting you will get rich by doing work for free! What I am suggesting is that you can make it work; you can make it worth your while. When that's the case, I would make the argument that you're not really working free. You are in fact getting paid—and sometimes paid more than if they had offered up cash.

The key here is to ensure you are on the same page with the people you are doing this work for. Make sure you are communicating with them about what you expect in return. Maybe it's access to their client list, a primo location at the next bridal show, display space for your prints, or access to their rooftop for some cool and unique location portraits. Are you getting the picture here? We run a very successful stu-

dio, so I don't need a few extra bucks from a vendor; I want access to something unique, something I would have to pay several hundred dollars for—or, in some cases, something money just can't buy. That's where the real payoff comes.

Just a word of caution here: I have seen many photographers chase their tails doing all sorts of free work and getting nothing in return—and they just can't seem to figure it out. Like anything else in life, if you allow people to take advantage of you, they will. So make sure you are getting something in return for your time and talent. Whatever it is, be sure you are happy with it. When it's all said and done, if the person you are doing this work for is unwilling to give you anything in return . . . well, the answer should be obvious.

8. VIDEO: A BRAVE NEW WORLD

Ablind man could see where the future of our industry lies. Depending on your perspective, you are either thrilled or scared to death. Yep. The future is video; there is no escaping it. We can all pretend it's not going to happen, just like the naysayers denied digital was the future. Well, look at us now; aside from a few niche applications, film is pretty much dead. We are digital-shooting fools today—and an entire industry has been born to support our digital overshooting habits.

If you have any vision whatsoever, you should easily be able to recognize that this is not going away. If you don't have vision, a quick trip to your local electronics store will reveal to you that the camera manufacturers aren't going to let it go either. They are seizing the opportunity to merge these two disciplines. And there are vendors galore lining up to support the birth of this new industry.

Now, we have a choice to make: we can be photographers or we can be creative directors. As photographers, we use our cameras to create and craft images. As creative directors, we use *all* the tools at our disposal to creatively direct and document our clients' biggest days. And just like a flash or reflector, video is another tool in our arsenal.

GETTING STARTED

We saw this coming back in 2009 and jumped in with both feet. I will tell you this: we had no clue what we were doing or getting ourselves into. All I knew was that this was our future—my future—and I had to be part of it. Happily, it has resulted in a huge revenue boost for our business and created a nice competitive advantage for us. It's yet another value-added feature for our clients.

Let me start here by telling you the crazy story of how we got involved in video. We had a bride who loved us. She booked us at a bridal show on the spot. However, she, like many of today's more modern brides, was very savvy about video. She wanted something more than just the boring church videos so many of today's videographers produce. She wanted something, in her words, "That matched the Salvatore Cincotta style of photography." What she wanted was for *us* to video her wedding!

When I told her I had no idea how to do this, that we had no experience with cinematography, she smiled and said, "I have complete faith in you. I know you will figure it out." And sure enough, we did. Talk about pressure! We begged, borrowed, and (practically) stole to get the gear we needed to document the day. Let me tell you, it was madness. Running video and

photography at the same time was no easy task, but I can't even explain to you the rush I felt working with this new tool. I was hooked! And we have never looked back.

ADVANTAGES OF OFFERING IN-HOUSE VIDEO SERVICES

I know what a lot of you might be thinking, "Is it really worth the added headache to offer this service?" Yes, it is. Not only is there more money in offering this, you create a level of separation between you and your competitors by offering both services in-house. Most importantly, you have creative control over the day, with no compromises. Plus, it's freaking awesome. I feel like a movie producer!

SELLING THE SERVICE

We offer video as an à la carte item. I don't recommend forcing it into your packages; ultimately, not every client will want this, so you will either lose clients or end up removing it for clients who aren't interested.

We do discount video coverage for clients who book both photography and cinematography with us. If they are in our top

> I can't even explain to you the rush I felt working with this new tool. I was hooked!

package, we give them 50 percent off video. However, if they are in a lower-end package, they might get a 25 percent discount on any video package. Pick your own discount structure, but the formula is simple—and if you recall our earlier discussion on packaging, this is all about creating compelling packages.

We do not allow people to book *just* our cinematography services. The reasons should be obvious: we are still a photography studio first and foremost. That is our primary service. Video is just a value-added type of service. (But our clients love it, so who knows where it will take us in the future?)

APPROACHES TO VIDEO SERVICES

You have two options to consider as you plan your jump into the video game. First, you can go at it from a fusion perspective, adding snippets of video to your still photography with some audio to produce a collage of imagery. Or, you can go at it from a cinematography perspective and provide a full video service offering to your clients. There are some pros and cons to each.

Fusion Approach
- It's easy to get started and the investment costs are low.
- You can use the camera, tripod, and lenses you already have.
- It's a great add-on service for your clients.
- The presentation can be produced without a lot of complex editing software.
- You can add this service without adding staff.

Cinematography Approach
- It's harder to get started and the investment costs are higher.
- You can use some of the tools you have, but you will also need to add a lot of new tools and hardware.
- You must learn to use video-editing software like Sony Vegas or Apple Final Cut Pro.
- You'll need additional staff to shoot video.
- You have to do more multitasking. You will have to coordinate the day and allow time to shoot for stills *and* video—while ensuring the posing and activities you have the group participate in translate well to both mediums. Your creative process will and must change.

This is a long list of things to consider. I am sold on video, but you will have to decide for

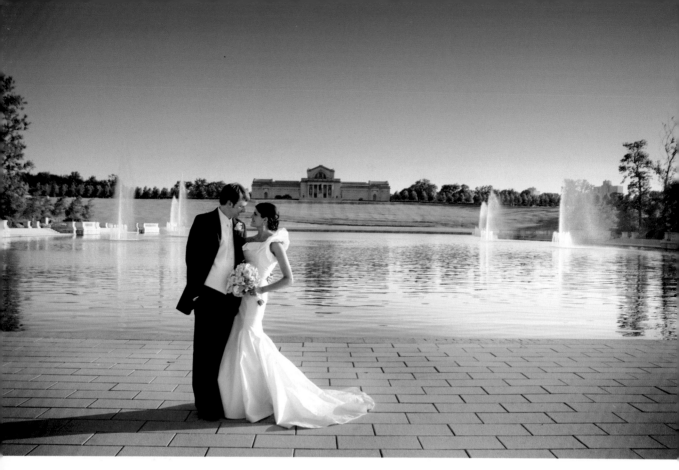

yourself how committed you are before you get started. We had to invest a tremendous amount of cash up front to ensure we had the right tools for the job (I am a big believer in the idea of doing things right if you're going to do them at all). There is more to cinematography than putting your camera in video mode. Just as in photography, there are rules—composition rules, timeline rules, motion rules, lighting rules, etc. This is a new discipline and you have to invest the time to learn it.

> There is more to cinematography than putting your camera in video mode.

TOOLS

Along the way, you'll need to add a slew of tools to your arsenal. Rather than go through every tool on the market, we will review the ones we have added to make our cinematography wing more productive.

Cameras. We shoot 100 percent Canon—in my opinion, their products are the best on the market. We currently use the 5D, 7D

and 60D. In addition, we use the Canon XH-A1s, which is a pro-series, tape-based camera. The main advantage of the 5D is that it has a full-frame sensor; as a photographer, you should know the value of that. On this camera, 35mm lenses look correct (as opposed to the crop factor of the 7D and 60D).

Lenses. We also use only Canon lenses. Some of our favorite lenses for video are the 35mm f/2.0, the 16–35mm f/2.8L II, and the 70–200mm f/2.8L USM. We have lenses to cover the entire range, but these three lenses get the most use. The best part of using the Canon DSLRs for video is that you get to reuse the lenses you already spent so much money on.

Memory Cards. We love Kingston cards. We use the 32G cards, which have enough capacity to get plenty of video—depending on the resolution you are shooting. The key here is get the fastest cards you can. The last thing you want to do is compromise the integrity of your video because your cards are too slow.

Batteries. Make sure you have plenty of spare batteries. Video chews through batteries a lot more quickly than still photography. At a typical wedding, we shoot the event's still photography without ever changing the batteries. When we are running video, however, the batteries have to be changed several times a day. Add the battery grip to give you that extra power.

Lighting. This is where there is a huge difference: you will need to add a continuous light source of some sort. There are many options on the market for you to consider. Of course,

cameras are getting better and better in low light, but there is still a lot of noise. This can make your video fall apart—especially if you are shooting in full HD. (*Note:* Adding a continuous light source will bring some nice polish to your still photography, too; we love shooting stills with our 50mm f/1.2L and 85mm f/1.2L when we have the video lights going. It gives the images a much nicer look than flash.)

Stabilizers. The difference between a handheld shot and a supported, stabilized shot is the difference between an amateur video and a professional film. There are all sorts of options out there. We use two main devices: normal tripods for panning and tilting and the GlideCam 4000 HD for full-motion shots. The GlideCam allows you to get a full-motion shot that looks like something filmed on a big-budget Hollywood film. I can't stress the importance of keep-

We love the Sima lighting units. We have over twenty of them in our bag for a multitude of uses.

ing camera shake out of your video production. It makes a huge difference in the final product.

Software. Whether you work on a PC or Mac, there is software for you. However, you are not going to be able to edit this footage with software from the box store; you are have to invest in pro-level editing software. You will face some complicated editing issues when you start working on your footage, and using pro-level software will allow you to address these challenges more easily and produce a high quality product. In most cases, you will be producing a full HD Blu-Ray disc for your clients, something that is typically supported only by professional editing software.

Computer. When you are working with the video files, the raw files are compressed. They typically have to be decompressed to a high-quality format before you can begin editing. (*Note:* This is quickly changing; by the time this book is released, you may be able to edit with the native camera files.) All this decompressing and rendering is computer-intensive, so you will need a fast, updated computer to work with your video clips.

Hard Drives. The next most important computer resource is hard drives. You will need a lot of additional hard drive space— and you'll want fast drives. This will feed your video editing timeline; if your drives are slow or the connection speed is slow, you will want to pull your hair out when trying to work on your timeline.

Television Output. Video, unlike photography, cannot easily be color-corrected using a computer monitor. The color space is completely different on a television (where the video will be viewed), so you will need to add a television output to your computer to correctly color correct your video footage. This is especially important if you are shooting video on multiple cameras where the white balance is going to be a little different from camera to camera.

Audio. Sound is a critical element when producing video, yet it is quite often overlooked. Any story worth telling has an au-

Our 5D on a Glidecam 4000HD.

Video, unlike photography, cannot easily be color-corrected using a computer monitor.

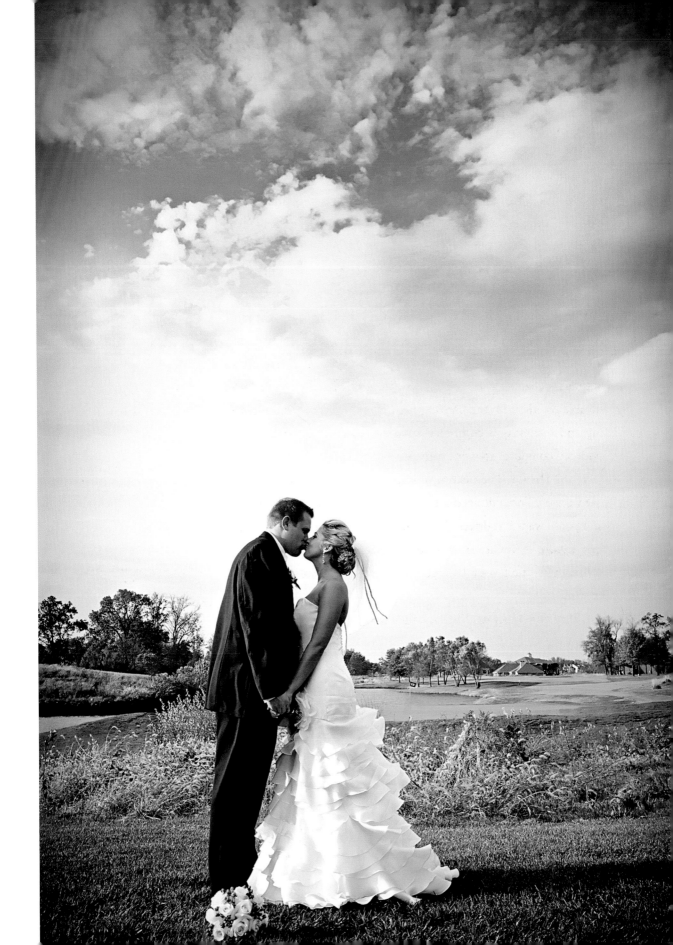

The H2 is a very versatile little tool and provides for a much cleaner audio source.

dio component to it. Since cameras' on-board microphones are pretty much junk, you will need an alternate source of audio—especially to capture key moments like the couple's vows, the toasts, and any other moments critical to the narrative. (*Note:* We also like have our couples write each other a note, then open and read it on camera.)

To capture audio, we use the H2 by Samson Audio, an amazing little device at an unreal price point. There are definitely more expensive and feature-rich products on the market, but this gets the job done. What I love most about the H2 is its line-in feature, which allows me to get audio straight from the DJ's sound board. Trust me—if you want your video to look amateur, screw up the audio. Shaky video and bad audio are two telltale signs.

IN CLOSING

Again, this is not meant to be a full-on review of video—I could write an entire book on that topic! I just want you to be aware of where the industry is going, the opportunity in the market, and the challenges you will face as you consider entering this exciting new world. Whatever you decide to do, do it well. Invest the time and energy required to learn about this new craft.

INDEX

Hollywood Lighting

Learn how to use hot lights to create dramatic, timeless Hollywood-style portraits that rival the masterworks of the 1930s and 1940s. *$34.95 list, 7.5x10, 160p, 148 color images, 130 diagrams, index, order no. 1956.*

Flash and Ambient Lighting
FOR DIGITAL WEDDING PHOTOGRAPHY

Mark Chen shows you how to master the use of flash and ambient lighting for outstanding wedding images. *$34.95 list, 8.5x11, 128p, 200 color photos and diagrams, index, order no. 1942.*

Lighting Essentials

Don Giannatti's subject-centric approach to lighting will teach you how to make confident lighting choices and flawlessly execute images that match your creative vision. *$34.95 list, 8.5x11, 128p, 240 color images, index, order no. 1947.*

BILL HURTER'S
Small Flash Photography

Learn to select and place small flash units, choose proper flash settings and communication, and more. *$34.95 list, 8.5x11, 128p, 180 color photos and diagrams, index, order no. 1936.*

Studio Lighting Unplugged

Rod and Robin Deutschmann show you how to use versatile, portable small flash to set up a studio and create high-quality studio lighting effects in *any* location. *$34.95 list, 7.5x10, 160p, 300 color images, index, order no. 1954.*

Wedding Photographer's Handbook, 2nd Ed.

Bill Hurter teaches you how to exceed your clients' expectations before, during, and after the wedding. *$34.95 list, 8.5x11, 128p, 150 color images, index, order no. 1932.*

Master's Guide to Off-Camera Flash

Barry Staver presents basic principals of good lighting and shows you how to apply them with flash, both on and off the camera. *$34.95 list, 7.5x10, 160p, 190 color images, index, order no. 1950.*

Wedding Photojournalism
THE BUSINESS OF AESTHETICS

Paul D. Van Hoy II shows you how to create strong images, implement smart business and marketing practices, and more. *$34.95 list, 8.5x11, 128p, 230 color images, index, order no. 1939.*

Engagement Portraiture

Learn how to create masterful engagement portraits and build a marketing and sales approach that maximizes profits. *$34.95 list, 8.5x11, 128p, 200 color images, index, order no. 1946.*

WES KRONINGER'S
Lighting Design Techniques
FOR DIGITAL PHOTOGRAPHERS

Create setups that blur the lines between fashion, editorial, and classic portraits. *$34.95 list, 8.5x11, 128p, 80 color images, 60 diagrams, index, order no. 1930.*

Family Photography

Christie Mumm shows you how to build a business based on client relationships and capture life-cycle milestones, from births, to senior portraits, to weddings. *$34.95 list, 8.5x11, 128p, 220 color images, index, order no. 1941.*

UNLEASHING THE RAW POWER OF
Adobe® Camera Raw®

Mark Chen teaches you how to perfect your files for unprecedented results. *$34.95 list, 8.5x11, 128p, 100 color images, 100 screen shots, index, order no. 1925.*

BRETT FLORENS' Guide to Photographing Weddings

Learn the artistic and business strategies Florens uses to remain at the top of his field. *$34.95 list, 8.5x11, 128p, 250 color images, index, order no. 1926.*

Advanced Wedding Photojournalism

Tracy Dorr shows you how to tune in to the day's events and participants so you can capture beautiful, emotional images. *$34.95 list, 8.5x11, 128p, 200 color images, index, order no. 1915.*

Creative Wedding Album Design WITH ADOBE® PHOTOSHOP®

Mark Chen teaches you how to master the skills you need to design stunning and unique wedding albums. *$34.95 list, 8.5x11, 128p, 225 color images, index, order no. 1891.*

On-Camera Flash TECHNIQUES FOR DIGITAL WEDDING AND PORTRAIT PHOTOGRAPHY

Neil van Niekerk teaches you how to use on-camera flash to create flattering portrait lighting anywhere. *$34.95 list, 8.5x11, 128p, 190 color images, index, order no. 1888.*

Off-Camera Flash

TECHNIQUES FOR DIGITAL PHOTOGRAPHERS

Neil van Niekerk shows you how to set your camera, choose the right settings, and position your flash for exceptional results. *$34.95 list, 8.5x11, 128p, 235 color images, index, order no. 1935.*

500 Poses for Photographing High School Seniors

Michelle Perkins presents head-and-shoulders, three-quarter, full-length poses tailored to seniors' eclectic tastes. *$34.95 list, 8.5x11, 128p, 500 color images, order no. 1957.*

500 Poses for Photographing Men

Michelle Perkins showcases an array of head-and-shoulders, three-quarter, full-length, and seated and standing poses. *$34.95 list, 8.5x11, 128p, 500 color images, order no. 1934.*

500 Poses for Photographing Couples

Michelle Perkins showcases an array of poses that will give you the creative boost you need to create an evocative, meaningful portrait. *$34.95 list, 8.5x11, 128p, 500 color images, order no. 1943.*

500 Poses for Photographing Women

Michelle Perkins compiles an array of striking poses, from head-and-shoulders to full-length, for classic and modern images. *$34.95 list, 8.5x11, 128p, 500 color images, order no. 1879.*

MORE PHOTO BOOKS AVAILABLE

Amherst Media®
PO BOX 586
BUFFALO, NY 14226 USA

Individuals: If possible, purchase books from an Amherst Media retailer. To order directly, visit our web site, or call the toll-free number listed below to place your order. All major credit cards are accepted. *Dealers, distributors & colleges:* Write, call, or fax to place orders. For price information, contact Amherst Media or an Amherst Media sales representative. Net 30 days.

(800) 622-3278 or (716) 874-4450
Fax: (716) 874-4508

*All prices, publication dates, and specifications are subject to change without notice.
Prices are in U.S. dollars.
Payment in U.S. funds only.*

WWW.AMHERSTMEDIA.COM
FOR A COMPLETE LIST OF BOOKS AND ADDITIONAL INFORMATION